BAR HARBOR

IN THE

ROARING TWENTIES

BAR HARBOR

— IN THE —

ROARING TWENTIES

*From Village Life to the High Life on
Mount Desert Island*

LUANN YETTER

THE
History
PRESS

Published by The History Press
Charleston, SC 29403
www.historypress.net

Front cover, top: Courtesy of the Northeast Harbor Library.

First published 2015

Manufactured in the United States

ISBN 978.1.62619.246.1

Library of Congress Control Number: 2015934851

Notice: The information in this book is true and complete to the best of our knowledge. It is offered without guarantee on the part of the author or The History Press. The author and The History Press disclaim all liability in connection with the use of this book.

To Nate:
thanks for all your help.

CONTENTS

Foreword

In France, the era is called *années folles*, the "crazy years," a time of tumult and change as the gloom of the Great War gave way to new forms of expression and a charged-up economy funded cultural innovation, new ways of making a living and all kinds of mischief. In *Bar Harbor in the Roaring Twenties: From Village Life to the High Life on Mount Desert Island*, Luann Yetter explores this era, taking a deep dive into a single decade and a singular place.

The historiography of Mount Desert Island is voluminous but still incomplete. There are dozens of books, articles and essays that range from the efforts of eager amateurs and breezy personal memoirs by sophisticated writers to primary source material recorded in first-person recollections of village life and real works of enlightening scholarship. None have tackled the history of Mount Desert Island as Yetter has done. She places herself inside a particular place and time and reports the major stories of the day as they happened. One gets the impression of shadows sliding over a solid landform, like thunderstorms flying past granite mountains. The war ends, and in a sense, the sun comes out. A brutal winter gives way to spring. A great airship looms over Bar Harbor and then sails down the wind. The unruly passions of both the rich and the middling strut for their moment on the stage, but they, too, must exit.

Yetter tells her readers what it was like to be there and to read the news of the time. She begins with a community awakening from the dark days of the Great War, mourning the losses of so many young men but also spilling into euphoric revels at the Bar Harbor Casino, Hayseed Balls and a Victory

Ball. There was a sense of a new world awakening, with islanders about to obtain a share of the prosperous times to come. Alcohol—liberally dispensed despite the restrictions of the Volstead Act—was a factor in the euphoria. As *Bar Harbor Times* editor Albion Sherman wrote, "People throughout the country will feel more like spending their money and will feel easier about leaving their business to go away for the summer months."

The scene is visited by rumrunners and other outrageous characters, some in the guise of the sophisticated and upright and others as islanders so tender they fed the seagulls and ducks to keep them from starving during the brutal winter of 1923. The magnificent creations of humans and nature arrive in the form of the 625-foot-long airship *Shenandoah* and a tsunami, an 8-foot wall of water that awed but did not frighten the sturdy people of Bass Harbor. Strong women assert their place in society, and wealthy families are both generous and dissolute. Yetter concludes with a description of the tremendous concentration of wealth and the wealthy that accumulated on Mount Desert Island at the close of the decade.

Through it all, Yetter keeps *Bar Harbor in the Roaring Twenties* grounded in what is not fleeting—the solid core of the island landscape and the people who made it their home through the years.

TIM GARRITY
Executive Director
Mount Desert Island Historical Society
December 2014

CHARMED AWAY

Unsurpassed beauty. That's what attracted visitors to Mount Desert Island. In the 1920s, they came in droves and fell in love with what they found. "A man who can spend a vacation in this region and not have his cares and worries charmed away must have a soul that is dead," pronounced visitor Albert Gray in 1921.

At the center of visitor activity on the island was Bar Harbor, a town of some 2,500 year-round residents on the shores of Frenchman's Bay that had become accustomed to catering to summer people since the post–Civil War years. "A veritable little metropolis is this summer capital," noted Gray. "One has jumped in a single leap from the quaint, simple Maine coast villages into a real live city." Grand hotels with American plan meals anchored several neighborhoods while wooden storefronts on Main Street offered fishing tackle, yachting pennants, Moxie soda, ladies' wristwatches, Eastman cameras and men's hats of "smart styles in harmony with good taste." Ferry service from the Maine Central Railroad on the mainland connected travelers by rail with all of the Atlantic Coast and beyond.

Visitors had been coming to Bar Harbor for years by rail and boat, but the 1920s saw a new breed of tourist roar into town. Automobiles had become popular on the mainland in the early 1900s, but until 1913, the noisy new contraptions had been banned from the island, where the summer people wanted to keep their leisure colony quaint and livery stable owners wanted to keep their horses and buckboards in demand. The ban had been lifted just before the Great War. During those war years, Bar Harborites had started to

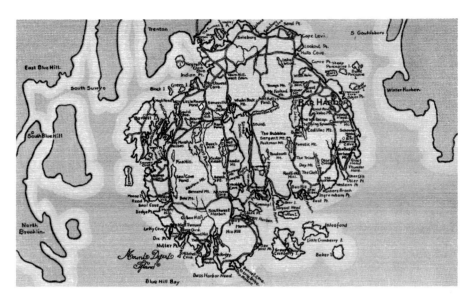

Map of Mount Desert Island, circa 1930. *Courtesy of Boston Public Library.*

become accustomed to the motorized vehicle, but summer visitor numbers dropped dramatically. With the war over, local business people were very eager for their tourist business to pick up again, and in the motorist, they found a new customer who would come to view the island scenery, stay in a local hotel or pitch a tent in one of the new campsites and then roar away within a few days. By the early 1920s, hotels were competing for prominence as "the logical Bar Harbor hotel for the motoring party."

Meanwhile, the old guard, the wealthy and powerful, still came for the entire season, as they had since the late 1800s. The rugged shoreline, the granite peaks and the wild forests reminded them that, despite never leaving the East Coast, they had found wilderness. They happily deemed themselves to be "rusticators" and built mansions they called "cottages." They patted themselves on the back for toughing it out in such a dramatic landscape as they meanwhile organized formal balls at their Swimming Club, hosted sailing events in Frenchman's Bay and played tournaments at their golf club in Kebo Valley.

"Bar Harbor is the one watering place that might compete with Newport socially," proclaimed *Harper's Bazaar* in 1922. John D. Rockefeller of the Standard Oil Rockefellers and Edsel Ford of the automobile Fords, along with blue bloods like Philip Livingston whose wealth was so old that nobody knew how their families had acquired it, summered on the island during the '20s.

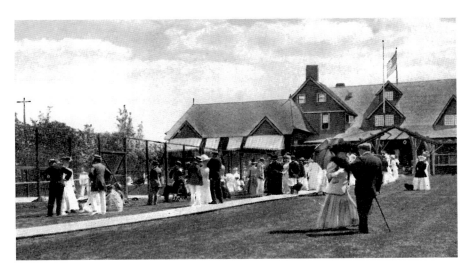

Bar Harbor Swimming Club. *Courtesy of Jesup Memorial Library, Bar Harbor.*

Another attraction on Mount Desert Island receiving more and more motor visitors and increased patronage from the rusticators in the '20s was the new national park. In 1916, the ten-thousand-acre site, then called Sieur de Monts National Monument, had become the first national park on the Atlantic coast. It was renamed Lafayette National Park after the French general who had distinguished himself in the American Revolution. The name was selected in the wake of the war years to honor France as the United States' recent ally. "The Lafayette National Park, small though it is, is one of the most important members of the national park system," wrote Robert Yard in his 1921 book about the country's national parks. "It is a region of noble beauty, subtle charm and fascinating variety." It was this variety that made Lafayette stand out, even when compared to the older, more famous parks of the west like Yellowstone and Yosemite. Outdoors enthusiasts were attracted by the numerous activities, and Yard mentioned several: "sea bathing, boating, yachting, salt-water and fresh-water fishing, tramping, exploring the wilderness and hunting the view spots."

"The coastline is torn and tattered, with great humps pushing their way upward, no matter where one looks along this section of the Pine Tree coast," noted Gray, who explored the island with his family in their cruiser, *Scout.*

Visionaries, such as park founder George Dorr and world-famous landscape architect Beatrix Farrand, actively promoted the beauty and special qualities of their island in an effort to preserve the natural landscape. They praised

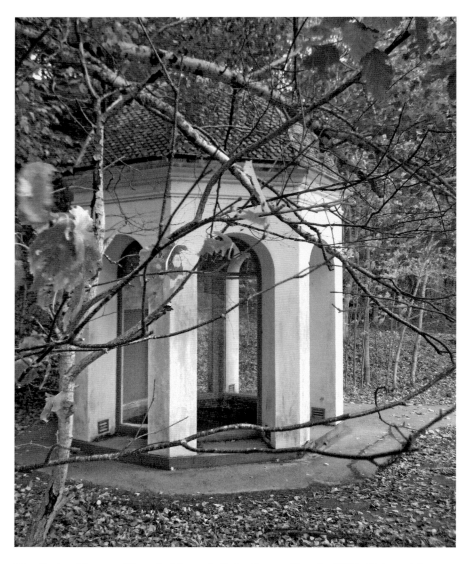

The Spring House at Sieur de Monts, built by George Dorr in 1909. *Photograph by Luann Yetter.*

their mountains as something extraordinary. "Their ice modeling has been on such noble lines that they seem larger than their natural height, and the cliff and rock formations are also on a big scale," said Farrand. Big, and primeval as well. "Its rocks are among the most ancient in the world," explained Dorr. "The Alps and the Himalayas are young compared with them."

And among the rocks, there was a notable collection of greenery. "The cool nights followed by clear, sunny days give herbaceous plants a brilliance of color and vigor of growth which cannot be found except in the high Alpine meadows," wrote Farrand. "The forests on the island are unusually varied in their leafage; they are really only comparable to the forests of Japan in complexity of texture, but a certain radiance and beauty of coloring is all their own."

Country Life magazine gushed over the coast of Maine in the 1920s and called Mount Desert Island "the culminating point of grandeur." The loveliest of the lovely, many said, was Somes

George Dorr. *Courtesy of the National Park Service.*

Sound, where Abraham Somes had made the island's first permanent white settlement in the 1700s. *Country Life* noted that it was "considered by many to be the most beautiful body of water on the Atlantic Coast."

Even those who made Bar Harbor their year-round home, who knew the brutal winters and chilling springs, were captivated by how "green and blue and lovely" it all was in the summer. "It filled the eyes; it shook the senses," recalled local resident Sylvia Kurson. "It was a truth beyond imagination."

Like their summer neighbors, the locals of Bar Harbor were private and conservative by nature. But gradually, they had found themselves caught up in a lucrative economy dependent on the wealthy summer visitor, and townspeople were proud to think that their community held so much attraction. Besides, the rusticators provided a constant source of entertainment for the locals. "Summers there were a living drama acted out by the fabled rich, with their chauffeured limousines, their gymkhanas [horse shows], and sailing races," recalled local resident Sylvia Kurson. "We could watch the never-ending show and marvel. "

"Everyone seems to have nothing to do, and to be very busy doing it," noted Gray. He noticed too that the locals shared in the summertime enchantment of the place. "Even those who are busy 'making hay' while the summer visitor shines," he wrote, "seems to have nothing particular to do in this world but enjoy themselves."

Year-round resident Nan Wescott Cole felt much the same. In later years, she remembered the feeling of leading "a double life" as a young woman in the '20s when locals worked around the clock in July and August serving some of America's richest and most prominent families and then enjoyed the fruits of their labor in a quieter atmosphere the rest of the year. They were barred from some of the cottagers' most desirable clubs, "but we felt no resentment or sense of exclusion," she claimed. In fact, townspeople "reveled in being part of the local grapevine, privy to intrigues and escapades of which outsiders had no inkling." What these escapades were, Cole wasn't telling, even years later, but perhaps she was making reference to the illegal liquor that would seemingly appear out of nowhere for the illustrious visitors.

Bar Harbor in the '20s was one of the most desirable locations in the country in the summertime but also one of the harshest and most isolated

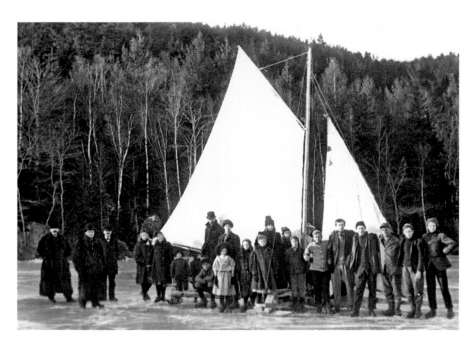

A group with an iceboat on Lower Hadlock Pond, 1910. *Courtesy of Northeast Harbor Library.*

in the winter. The wealthy visitors referred to July and August on the island as "the Season" while the "natives," as they often called themselves, knew the rest of the story: the Northeast storms that could bring over two feet of snow, the frigid cold that prevented hens from laying eggs and lobster boats from leaving frozen harbors, the sixty-mile-an-hour winds that could make mountains out of waves and the frozen sleet sheathing coastal windows. Year-round residents banded together in the winter and did what communities do to make the best of their circumstances. They gathered at St. Saviour's or the Holy Redeemer for church services and public suppers, they threw parties and dances or watched their teenagers play basketball and act in plays at the municipal casino, they played charades in cozy living rooms heated with coal stoves and they watched movies with live piano accompaniment at the Star Theatre. In the coldest of months, when even the earliest of tourists or latest of the summer residents were somewhere south of Mount Desert Island, never giving a thought to island winters, life went on in Bar Harbor. Without the distraction of the summer crowds to worry about, those who remained had time to concentrate on one another.

Inevitably, the population was dramatically divided between those who only came for the loveliest of weeks and those who persevered throughout the year. Yet the locals knew their lives were shaped by the fortune of being born into such natural beauty and by the varying and rich parade of visitors attracted to the wonders of the place they called home.

Righteous Wrath Appeased

The Catholics, the Episcopalians and the Congregationalists all rang their bells. Selectmen blew whistles. Bar Harbor Band members tooted their horns. At noon, the students were released from school, and young boys raced home along Cottage Street to retrieve the firecrackers they had waiting, eager to add their pyrotechnics to the din. Shopkeepers along Main Street hung their flags and closed their stores. Old men pulled out their Civil War revolvers and shot them in the streets. From the harbor, twenty-one rounds of gunfire echoed from the USSP *Tylopha*. As the November evening fell early, the cadet band and naval reserves marched through the streets in their brown wool uniforms to the Athletic Fields, where two hundred tar barrels were torched, their flames and fumes of black smoke wafting into the night sky. *Bar Harbor Times* editor Albion Sherman was on hand to cover the event, as he had covered all the big news stories since becoming editor the year before. "Underneath the swirling noise," he wrote, "there rang the undercurrent of righteous wrath appeased." In the center of the commotion hung an effigy, the flashpoint for all this righteous wrath: the Kaiser. In the midst of a cheering crowd of hundreds, Otter Creek sailors mercilessly rammed the villainous Kaiser with bayonets and then gleefully threw the remains into the choking black smoke.

Bar Harbor's spontaneous response to news that the world war had finally and officially ended looked something like war itself. And finally, after all the outdoor chaos, the hell-raisers poured into the municipal casino, where the

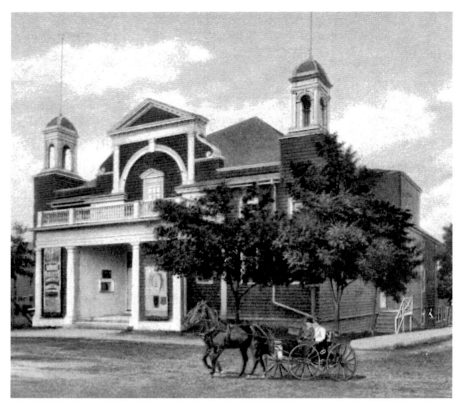

The casino. *Courtesy of Jesup Memorial Library.*

pandemonium continued in music and dance until the sun came up over Frenchman's Bay.

War reports had been coming in from overseas for over a year. Bar Harbor boys wrote from "somewhere in France" to assure their families that they were all right and to include a few bits of news from their travels: they were learning a few words of French or meeting soldiers from all parts of the United States and all over the world. But by the time George Sullivan wrote home at the end of October 1918, traces of the real war were creeping into his letter. "The whole country around is all blown to pieces," he wrote. "No trees left to speak of, and the ground is in awful shape. We came through some towns on our way to this position that were just blown off the map. No one knows what war is until they see for themselves."

Even as Bar Harborites took to the streets to celebrate the war's end, the news from abroad remained tragic. Lester Lurvey's family in Northeast

Harbor had just learned that he had been killed in action on the first of October while taking wounded from the field. Herbert Reed's family in Tremont celebrated with everyone else on Monday only to learn on Tuesday that Herbert had died of pneumonia in France. Russell Emery left a wife and three children when he met his death in European waters on an oil tank steamship. Dean Edwards from Hulls Cove died in an accident at sea in the Merchant Marine Service. All these deaths coming in November, so near the time of the armistice, made such losses even sadder. But the deaths of Bar Harbor's own had been casting a shroud over the town since the country's entry into Europe's war in 1917 and especially after the furious battles of the summer of 1918. Of the 270 men from Bar Harbor who were sent into service, 11 never returned.

No loss hit the community harder than the news that came a month after the armistice celebration. George Kirk had died on a hospital bed somewhere on the edge of the Argonne Forest. Everyone in Bar Harbor knew George. A friendly boy and good athlete, he was the son of Ed Kirk, who had first come to Bar Harbor in 1888 to work on the Vanderbilt estate and had remained to serve as superintendent of the estate ever since. George had exceeded expectations for the son of an Irish Catholic laborer; he had gone on to the University of Maine, where he had continued to excel in basketball and especially football, earning the title of All-Maine halfback. His senior year, he transferred to Susquehanna, where he continued his football career. A month after Congress voted to declare war ("the war to end all wars" according to President Woodrow Wilson), Kirk left Susquehanna for Fort Niagara and officer's training. He sailed for France in October.

"Am working hard," he wrote home in January. "Six or seven hours of drill a day in a tin hat is no cinch—but war isn't an easy game I'm learning more and more each day." He explained that he was billeted with a family in a French village (he was not allowed to give the name) and that he was picking up a few words of the native language. "Who ever heard of a Mick speaking French anyway?" he joked. Like most soldiers, George tried to keep his letters upbeat, but sometimes the longing for home would creep in. "If I ever get back to little ol' Bar Harbor again," he said, 'I'm going to stick."

By summer, George had been promoted to second lieutenant, and his machine gun company saw intense action: the Battles of Chateau Thierry and St. Mihiel wiped out nearly all of his company, but George managed to suffer only from gas sickness and was left uninjured. His gallantry in battle earned him another quick promotion to captain.

In October, two old Bar Harbor friends met up across the Atlantic in France quite by coincidence. George was in a taxi when he spotted his high school friend John Ash, now a lieutenant, on a street in France. He jumped out of the taxi and ran up behind him, grabbed his arm and swung him around. According to Ash, seeing his old pal from home was "the shock of my life." George was in town for a two-hour leave, "looking fine," according to Ash. "[He was] in the best spirits. The same old George." But soon after his meeting with Ash, George was overcome by pneumonia. He had already been in the hospital for a few weeks when the war ended. Desperate to march at the head of his company into conquered Germany, he left the hospital against his doctor's orders. George marched proudly into Germany with the Allied forces, but a few days later, he was sent back to the hospital in a delirious condition. A few days after that, amid the celebrations of the end to war, George died in his hospital bed, a nurse by his side. Back home, Bar Harborites were stunned after his parents received the news in a letter from the nurse. He was such a strong, capable young man. They could believe he had survived Chateau Thierry and St. Mihiel. They weren't surprised that he had acted with valor and lived when those around him were killed. That was the George they knew. But to succumb to illness and die when the war was over? Of all the hardships of the war, the death of George Kirk hit Bar Harbor the hardest. George's Church of Holy Redeemer held a Requiem Mass for him on a Tuesday morning in December. All the stores in town were closed while the services were conducted, and the town's leading citizens, Protestant and Catholic alike, gathered to mourn his passing. In the shadow of Christmas, a month after the they had laughed and cheered and congratulated one another—after they had lit their firecrackers, shot their hand guns and fired their three pounder in recognition of their victory—the community of Bar Harbor gathered to yet again acknowledge the tragic consequences of war.

Other gatherings that winter were happier affairs. During the winter of 1919, residents sometimes gathered at the Maine Central Wharf to say goodbye to soldiers who had been stationed outside town at the Otter Creek Naval Station. While many of Bar Harbor's young men had been overseas, the naval reservists and marines from Otter Creek had in some ways taken their place in the social life of the town. But now, with the threat of enemy invasion receding in the country's newfound peacetime, their numbers were getting reduced. As eager as the men were for their upcoming discharge from service, and as eager as townspeople were for Bar Harbor to return to its prewar setting, emotions still ran high as the residents and men alike

Maine Central Railroad wharf, Bar Harbor. Steamers docked here from 1884 to 1931. *Courtesy of Jesup Memorial Library.*

waited for the steamer that would take them off Mount Desert Island. "They have all been a very orderly and gentlemanly lot of men," observed the *Bar Harbor Times*, "and the people of Bar Harbor wish them good luck and success wherever they go."

As the *Pemaquid* pulled away from the dock, soldiers waved and called their goodbyes. From the deck of the steamer, they serenaded their well-wishers with songs like "Smile the While You Kiss Me Sad Adieu." In the crowd on land, many young women smiled through their tears as they watched the steamship and their favorite beaux recede into the blue of Frenchman's Bay. "Almost every marine had at least one girl down to say goodbye," wrote a *Bar Harbor Times* reporter, "and some had two or three."

Muriel Mayo was one local girl who would not say goodbye. She and her Otter Creek soldier, Herbert Howard from Winthrop, Massachusetts, quickly planned a Wednesday evening wedding at her parent's home on School Street, and Herbert left Bar Harbor a married man.

While the naval reserves had been discharged, 150 naval men at the Otter Cliffs Radio Station remained in service. "They have constantly requested and keenly desired service overseas," remarked Lieutenant Allesandro Fabbri, their commanding officer, but their technical skills made them more valuable in receiving transatlantic radio messages from the coastline of their own country. "They were indispensable to this important work and could not be replaced," said Fabbri.

Otter Cliffs Radio Station Operating Force, 1919. *Courtesy of the National Archives.*

Their important work continued, and the following May, they made history. During the war, the station had handled most of the official communication between Washington and the European battlefronts, but its activities and location had not been publicized. With the war over, their accomplishments were starting to get some press. In May, Fabbri and his

station made international news when they established a new record in radio communications. They were able to intercept messages from a navy seaplane 1,200 miles away and send it along to President Roosevelt in Washington, D.C., prompting the *New York Times* to hail Otter Creek as "the greatest receiving station in the world in many respects."

The naval reserve forces were dwindling, but in a matter of weeks after the end of the war, some of Bar Harbor's own young men were returning home. Harry Allen came back from the war after serving as an army motorcycle driver and dispatch rider at army headquarters in Verdun. Allen had been under shellfire several times on his motorcycle and once had it shot out from under him. That incident had left him unconscious for hours and resulted in a leg injury that kept him laid up in a base hospital in France for weeks and then in a rest camp in England, but now he was home to tell his tale.

Others, still abroad, were finally able to write freely. "As the censorship has been almost completely lifted on our mail, I will endeavor to give you an idea of the many cities we have viewed in our travels," wrote Bill Pelinsky to his mother back home in Bar Harbor. Pelinsky had been stationed on a submarine chaser, and in January 1919, he could finally write his family to tell them of his journey from Bermuda ("certainly a beautiful place") to the Azore Islands ("not so clean as Bermuda") to the Rock of Gibraltar, where they were disturbingly close to the enemy. "Just think, all we had to do was cross a bridge and we would have been interned in Spain," he recalled. From there, his submarine unit went to Corfu in Greece and used the island as its station, patrolling the Ionian Sea for enemy submarines from Greece to Italy. Pelinsky wrote from the region of Fiume (now in Croatia), where he was enjoying the company of other Americans. "Believe me we were mighty glad to see someone who could speak English," he wrote, "having been in Greece so long and hearing that Greek lingo." Pelinsky knew that some of his friends from Bar Harbor were already arriving home, but he told his mother that he would likely remain "on this side" several months longer. "Next June or July seems to be about the time we will arrive in the United States," he told her. "As the old saying goes, 'better late than never.'"

That winter, townspeople flocked to the Star Theatre to see *To Hell with the Kaiser*, in which the Germans make war on the world and the Kaiser ends up "in just the place you'd like to see him."

In February, Bar Harborites joined together for their annual Hayseed Ball, a tongue-in-cheek celebration of their traditional, down-to-earth lifestyles. While summer visitors donned long dresses, jewels and tuxedos for balls at the Bar Harbor Club in warmer months, the locals took a

decidedly different approach for their midwinter festivities. Old-fashioned, barn-worthy "hayseed clothes" were required for this event, and far from the judgment of high society, the natives could relax and have fun. "Bar Harbor people have many good times in the run of a year," noted the *Bar Harbor Times*, "and contrary to the opinion frequently expressed by those who know Bar Harbor only in the summer months, some of the best times of the year are had in the winter months."

A thousand invitations were issued for the ball, and at least that many people filled the casino on a Wednesday night. The Grand March was led by the elite forty Hayseeders, who entered into the ballroom decorated with straw, barn lanterns and cowbells. "New-style wiggly dancing" was prohibited for the night, and contra dancing was enjoyed instead. "The younger men and the girls may know all about fox trots and one-steps," said the *Times*, "but when the orchestra played a good old fashioned waltz they had to admit that their fathers and mothers and even their grandfathers could show them how gracefully a waltz could be danced." The *Times* proclaimed that "your true year-round Bar Harborite looks forward to the Hayseeders as he looks forward to town meeting, Fourth of July and Thanksgiving." In the winter of 1919, with the war behind them and what was sure to be the busiest summer season in years ahead of them, Bar Harborites celebrated more at their annual ball than they had since before the war.

2
OUR SHARE OF PROSPERITY

Now that the war is over," wrote Albion Sherman in the *Bar Harbor Times* in the spring of 1919, "people throughout the country will feel more like spending their money and will feel easier about leaving their business to go away for the summer months." It was time to remind the rest of the world about the wonders of Mount Desert Island and to lure back visitors, along with their newly carefree spirits and willingness to spend money on pleasure. "Bar Harbor with its many attractions and wonderful scenery should get its share of this prosperity and should be brought to the eyes of these people in all the ways possible," he claimed.

At a town meeting on a cold day in March, taxpayers approved an appropriation of one thousand dollars for advertising their town to the potential tourist set. In addition, they determined that some spring-cleaning was in order and vowed to freshen up their community. Living in an area with so many wealthy and powerful summer people meant that local officials could sometimes call on some impressive experts. After the town meeting, nationally known landscape artist Beatrix Farrand visited her summer home out of season to share her expertise with officials eager to create a village setting "worthy of the beauty of the natural scenery and that of the private estates."

Farrand spent a tireless week in Bar Harbor making presentations and meeting with local homeowners and business people to discuss her vision for landscape improvements. At her YWCA presentation, every seat in the assembly room was taken. "Bar Harbor has achieved new dignity and importance in being the chief entrance of the new Lafayette National

Beatrix Farrand photograph, taken in Santa Barbara in 1943. *Photograph courtesy of the Beatrix Farrand Society.*

Park," she told residents. "The town will gain incalculably from its nearness to the park and is sure to become more and more visited by tourists as time goes on." Illustrating her lecture with lantern slides and photographs, she persuasively showed current pictures of the town and "after" pictures to demonstrate her ideas. She was "exceedingly practical throughout," according to the *Times*, as she pointed out ugly spots in the village. A photograph of the waterfront included "Dump Wharf" and the coal plant, which led the audience to agree that "the entrance to Bar Harbor does anything but justice to the resort." She then showed the scene with her proposed changes in watercolor. Buildings were covered in latticework, patterned screens obstructed the worst of the views, flowers bloomed in new window boxes and a pavilion enhanced the scene. The current appearance of West Street near the docks also fell under her scrutiny as she pointed out that by planting a tree, a bush or a vine here and there, an ugly corner might be made attractive.

Townspeople had plenty of incentive for their revival efforts. By May, the *Bar Harbor Times* was enthusiastically reporting an "almost universal opinion that Bar Harbor is going to have many more people than usual this year." The recent "usual" had been the wartime years when the visitors to town were more likely to be marines and sailors stationed at the Otter Creek Radio Station than the typical summer rusticator. Many of the estates had kept their doors locked and shutters drawn throughout the somber summers of 1917 and 1918, but this season, locals were hired to unfasten the latches, polish the woodwork and sweep the verandas free of moldy fir needles. Four Acres was to be rented by Everett Macy and family, who had summered at

Bar Harbor before the war; the Louis McCagg house would be occupied by Edith Pulitzer Moore, who recalled childhood summers at nearby Chatwold, and Dr. and Mrs. Augustus Thorndike would return to occupy the Eyrie, which they had left closed up the previous summer.

After the 1918 fire that destroyed banker Ernesto Fabbri's Eden Street cottage, the Fabbris had decided to rebuild, and the new cottage was now complete. Mrs. Fabbri was in town readying the place for Ernesto's return from a trip to Italy. Ed Kirk, still mourning son George's death at the end of the war, was hard at work overseeing the painting of all the cottages and buildings on the Vanderbilt estate. Smaller houses were in demand as well. Almost every house on Albert Meadow in the Field had already been leased for the season or would be occupied by the owners. At the Louisburg Hotel, manager David Ushkow predicted he would have a full house beginning early in the season and looked for a "record business in 1919." Hotel manager Gerard Alley of the St. Sauveur felt optimistic, too. Advance bookings for the season were far better than they had been in the war years. This one could rival 1916, said Chester Westcott at the Newport, and 1916 had been one of the best seasons that Bar Harbor had ever had.

By June, optimism about the summer had grown only stronger. "There is no doubt now about the season of 1919 being one of the greatest seasons in the history of the greatest coast resort in America," wrote Sherman. "The whole island of Mount Desert is to see a season of almost unprecedented prosperity this year."

The optimists were right, and by July, the island was buzzing with activity. Women in new shorter skirts strolled along the Shore Path marveling at

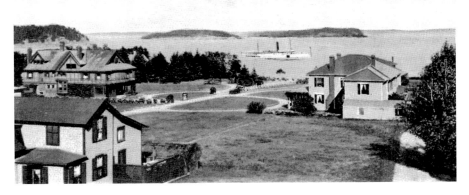

Cottages in "the Field." *Courtesy of Jesup Memorial Library, Bar Harbor.*

Louisburg Hotel. *Courtesy of Jesup Memorial Library, Bar Harbor.*

Balance Rock and showing off their now exposed ankles. Hikers tackled trails up Pemetic Mountain to gaze down at Jordan Pond below and treat themselves to popovers upon their return to the Pond House. Sailors raced their classic seventeen footers off Northeast Harbor while the younger set powered around the bay in fishing boats dolled up with fresh paint and varnish. Seaside inns featured broiled lobster and shore dinners of fresh clams and sweet corn, and picnickers took their baskets to the Ovens and then motored along Ocean Drive. Tennis courts at the YMCA and Swimming Club echoed with the sound of thumping tennis balls from morning until dusk, and at night, the casino was ablaze with light as dancers one-stepped and waltzed until the early hours at charity events like the Fireman's Ball, the Chauffeur's Ball and the Hospital Ball. The dollars were flowing from the wallets of the rusticators into the bank accounts of the locals.

In mid-July, the Eastern Yacht Club made its annual appearance, a bigger fleet than had visited Bar Harbor from its home in Marblehead, Massachusetts, in years. The fleet had left Swan's Island that morning, with many sailors getting an early start thanks to Swan's lobstermen, who left the harbor at daybreak in their muffler-less motorboats. "The impossibility of further sleep," noted one of the yachtsmen, "got the members of the club on deck at an early hour ready for the run to Bar Harbor." From shore, onlookers spent the warm July afternoon watching the yachts sail

Maine blueberries. *Pen and ink by Sara Tarbox.*

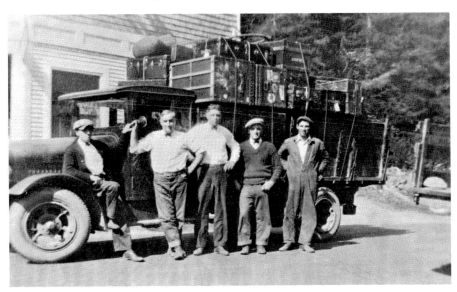

Mount Desert Island men transport luggage. Summer visitors rarely traveled light. Image circa the 1920s. *Courtesy of Great Harbor Maritime Museum, Northeast Harbor.*

gracefully into the bay, the classic schooners, sloops and yawls quietly gliding across the water one or two at a time. The modern steam and power yachts, commissioned for service in the war, had not yet been returned to civilians for pleasure cruises, and with twentieth-century mechanization missing from the fleet, the collection of vessels seemed to come from another era. By late afternoon, over twenty boats bobbed at anchor off the pier of the Reading Room. After the last member of the fleet had entered the harbor, Commodore Herbert Sears on the *Constellation* gave orders to dress ship. In response, every yacht unfurled its rainbow of flags and pennants of the international code from water line to water line, forward and aft, with American flags hoisted at the stern. For the old-timers, the site recalled a quieter age when the harbor had often been full of sailing yachts all summer long.

Many of the power and steam yachts had been destroyed or exposed to such rough use during the war that they had to be scrapped. Demand for new power yachts had never been bigger, and boat builders reveled in their booming businesses. Allesandro Fabbri, just recently relieved of command from the Otter Creek Radio Station after two years of war service, was one of many rusticators without a yacht in the summer of 1919, having donated his 160-foot ketch *Ajax* to the government at the beginning of the war. Somehow, J.P. Morgan had managed to get the navy to return the *Cosair* to him in time for the 1919 season, and many on Mount Desert Island said it was the most beautiful steam yacht afloat that summer.

Among all the boats filling Frenchman's Bay, none was more was more exciting to those on shore than the surprising arrival of a U.S. Navy N-1 submarine. Only a year before, that site would have triggered fears of an enemy spy vessel, but now, residents could feel confident that the knife-like mass of metal docked unnaturally low at the Eastern Steamship Company's wharf was friend, not foe. Bar Harbor's waterfront was soon crowded with curiosity seekers eager to get a close look at the first submarine ever to enter the harbor.

The Chautauqua also drew large crowds that summer. The traveling show took up residency at the Athletic Field on lower Main Street for a full week in July, offering lectures, concerts, recitals, dramas, operas and pageants. Crowds of visitors and townspeople filled the tent every afternoon and evening for entertainment such as Gilbert and Sullivan's *Pinafore* and Army Sergeant Ruth Farnum's stories as a female soldier fighting for Serbia in the Great War.

In the summer of 1919, national Prohibition had been ratified and was scheduled to take effect in the upcoming January. Maine, however, had long

been a dry state; the rest of the country was just catching up. As August was winding down, the Summer Cabaret Club staged "Remembrances of a Club Man," its last entertainment of the season at Bar Harbor's Swimming Club on West Street. It was "the most magnificent" show of the summer, according to the *Bar Harbor Times*. The summer colony group of amateur entertainers staged what it described as "a little sketch… part fantasy and part tableau." Prohibition was on the main character's mind when he was offered a drink, and he imagined "various beverages in vogue until recently." Young ladies of the summer colony appeared to him dressed as various drinks and "endeavored to get him to order them." Miss Harriet Zell, as Scotch whiskey, wore a Scottish highland costume as she came on stage dancing a Highland fling. Rye whiskey was typified by Miss DeFord, dressed in a simple country costume and carrying a sheaf of rye. Benedictine was personified by Miss Brewster. Entering as a hooded monk, she threw off her cloak to reveal an exquisite ball gown. The orchestra played background music during the cabaret portion of the evening and continued with music for the dance that followed. Summer colonists waltzed and fox-trotted until the early hours as their Victory Ball concluded the evening and, for many, the season.

Swimming Club members deemed their event a Victory Ball to celebrate the outcome of the war. But more than a celebration of victory, the event rang in a new era as well. The summer colonists would be back the following summer and all the summers to come in the 1920s. As the war receded from memory and their investments paid dividends beyond their wildest dreams, the fashionable set would dance until dawn, poke fun at Prohibition laws from their private clubs, cruise the bays in their flashy new power yachts and enlarge their seaside cottages to majestic proportions. Bar Harborites would welcome them back every summer as the celebration grew louder year after year.

3
ANOTHER ICE AGE

Two and half feet of snow, an all-time record, buried Bar Harborites in a storm during the first week of January 1923. That deluge turned out to be the beginning of a winter that left *Bar Harbor Times* editor Albion Sherman to theorize, only halfway joking, that "another Ice Age may be upon us." Crews had just succeeded in getting the roads passable from the first storm when a second nor'easter made conditions so much worse that their first job seemed easy by comparison. "The man who remembers more snow than covers the landscape of Mt. Desert Island today has not put in an appearance around the corner of Main and Cottage this week," Sherman proclaimed in the January 17 issue of his paper.

Where homeowners industriously shoveled their roofs, snow piled to their eaves. Businessmen took to shoveling tunnels to their entrances. In front of the Harris poolroom, local boys dug a tunnel to the street tall enough to walk through. With the overwhelming amount of snow rendering motorized vehicles useless, snow removal was out of the question. Residents gave up trying to haul away snow and simply tried to reposition the drifts, and the piles got higher.

In the decade since cars had been allowed, Mount Desert Islanders had become quite accustomed to their automobiles. But in the winter of 1923, their use was often out of the question, and residents had to rediscover the horse. The relatively few horses left in town were working overtime. Bar Harbor road commissioners employed four-horse snowplows that worked diligently during storms to keep roads passable. Outside the village, even

Somes Sound, Sargeant Drive, in 1923. Photograph by Robert Lindsay Smallidge. *Courtesy of Northeast Harbor Library.*

more effort was needed. A special plow was sent up the island to Hull's Cove, Salisbury Cove and Eden after the second storm, piloted by twelve big workhorses. Even with this twelve "horse power" outfit, the progress was anything but rapid, and both horse and crew were exhausted before they had rounded "the loop."

Boys and girls traveled to and from school on skis and snowshoes, and even some of the local businessmen were using snowshoes to get to their stores and offices in the village. The storms made life difficult for milkmen like Howe Smith, who had to wade through snow above his waist in order to supply his customers. During the second storm, Smith somehow managed to get into Bar Harbor to make his deliveries before the plow had even made it to his farm. He was four hours driving his good horse to town, a distance of eight miles, but the milk got delivered.

Members of the fire department kept four horses at the station and got busy putting the hook and ladder truck and all their equipment on runners. When they were called to a fire at the Naval Radio Station in Otter Creek in mid-January, only three men managed to answer the call, with two horses pulling a hose and chemicals. But even a quicker response wouldn't have prevented tragedy. The fire had started in the motion picture projection booth and spread rapidly. All fifty moviegoers—station personnel and Otter Creek residents alike—managed to escape, although some had to jump out the second-story window. The fire did $150,000 in damage to the station before firemen, navy personnel and

Fraser Peckham of Northeast Harbor, Sargeant Drive, in 1923. Photograph by Robert Lindsay Smallidge. *Courtesy of Northeast Harbor Library.*

Otter Creek residents completely extinguished it. Tragically, Radio Man Third Class Clifton Ward, running the equipment in the projection room, had been trapped by the flames and perished in the inferno. After a Baptist funeral service, his remains were sent to his home in Longville, Louisiana.

The task of keeping the naval radio station workers at Otter Creek supplied with food and mail during the crippling series of storms fell to veteran liveryman James Foley. After the second big nor'easter, Foley left for Otter Creek at eleven o'clock on a Sunday morning and did not reach the station until five that afternoon, taking six hours to make the five-mile trip. "And I had a good pair of horses too," said Foley, who went on to tell of drifts three feet above his horse's ears. Getting there was hard enough; turning around and getting back could wait for another day. Foley kept his horses in the station garage that night and bunked with the service men.

As the second nor'easter was building on Friday morning, Captain Brown and his U.S. Coast Guard crew, stationed at Islesford on Little Cranberry, heard a distress signal and set off right away through the blizzard. They found a schooner wrecked along the ledges and the eight passengers trying desperately to stay sheltered from the driving winds and snow. The Coast Guard quickly went to work rescuing the captain, his wife, a crew of six and their pet bulldog from their three-masted schooner, *Don Parsons*, but the ship itself was a total loss. Laden with a cargo of seven hundred tons of hard coal, the sailors had been on their way home from New York City to Nova Scotia when they got caught in the violent winds. As Brown had tried to make Southwest Harbor, his ship was flung onto

the ledges, where he and his crew had to hold on and hope that their distress signal would be heard.

Still tending to those storm victims, the Islesford Coast Guard crew was called back out into the blizzard a second time Friday night. On the southern end of Great Cranberry Island, crew members found another three-master, the *General George B. Hogg*, had been thrown onto the ledges. One by one, the Coast Guard removed Captain George Haughn and his five-man crew off the wrecked schooner to safety. Back at the Coast Guard station, Captain Haughn explained that he had tried to find shelter and had anchored off Baker's Island Friday afternoon, hoping to wait out the storm. But the winds were so fierce that both chains gave way and the crewmen found themselves piled onto the ledges. The *Hogg*, too, had about three hundred tons of coal aboard and was also returning to Nova Scotia.

A couple days later, when the winds were calm, many of the locals boated out to the Cranberries to see the shipwrecks. "The *Don Parsons* is broken up by the waves and her cargo thrown up on the shore or washed away. The *General George B. Hogg* on the ocean side of Great Cranberry Island has a hole in her bottom but is still in an upright position," reported a correspondent from Southwest Harbor. "It is certainly a sad sight to see the pitiful wreck of what was a stately ship,"

Around the wreckage and on nearby beaches, spilt coal was piled several feet deep, and eager visitors shoveled it up and carried it above the reach of the tide. The coal barge expected in the area earlier in the week had been delayed at Thomaston, where it couldn't dock because of an iced-in harbor. Thankful residents of Islesford managed to save a good supply of fuel for themselves, and boats from the coast towns for miles around took away many tons.

In January, a measles epidemic swept Cranberry Island, causing the grade school to open late for winter term and laying low many adults as well as children. One of them was twenty-eight-year-old Georgia Stanley, whose measles quickly progressed to pneumonia. Her condition was so serious that Dr. George Neal came from Southwest Harbor to care for her for four days and nights, but Georgia could not hang on. She passed away leaving behind husband Merrill and their two young children.

As the winter's unremitting cold continued, ice chunks formed in Cranberry Harbor. The ice became too thick for most boats but not thick enough to walk on, making navigation nearly impossible. But as sickness continued to plague the island residents, Dr. Neal remained determined to care for his patients despite the conditions. Dr. Neal managed to get the

revenue cutter *Ossippee*, which was big enough to cut through the ice, to take him to the island. But the ship had urgent calls to transport other patients off islands to hospitals, so it couldn't wait for the doctor to return him to the mainland. Dr. Neal saw to his patients, and then, knowing others back in Southwest Harbor needed him as well, he was determined to get back home. He enlisted the help of some of the island men, and since the weather was intensely cold, they thought they might be able to walk on the ice. They put Dr. Neal in a boat, with several men on foot pushing him across the ice while some went ahead with poles to test the conditions. The procedure worked until they were about halfway across. There the ice was thinner and suddenly began to give way. As the ice began to crack under their feet, the men quickly jumped into the boat, saving themselves from the freezing bay. They managed to get the boat back onto solid ice and then push it back to Cranberry Island, where they built a fire to warm themselves and then decided to try a different tactic. They dragged the boat to the open water on the southern end of the island, where they could row Dr. Neal across the Western Way back to Seawall Road on Mount Desert, from where he could walk four miles back to his home on the Main Road in Southwest Harbor.

The storms gave way to a windless bitter cold that by February had frozen the Western Way solid from Southwest Harbor to Great Cranberry. For the third season in five years, the ice was thick enough to bear travelers between MDI and many of the outside islands. Previous to that, it had been forty-three years since the ice had been so thick. Many MDI residents enjoyed the novelty of walking a couple miles across the ice to Great Cranberry, and many island residents walked to Southwest Harbor for food supplies, which had been getting low when navigation had been impossible due to the floating ice. The mail carrier walked across the ice pulling his mail sacks in a punt lashed to a hand sled.

But there was no walking to Mount Desert Rock, and no boat travel from Southwest Harbor, which meant no mail or visitors for weeks for the Beal family on their far-flung ocean outpost. Stationed on Mount Desert Rock Light, lighthouse keeper Vinal Beal, his wife and two children were without even phone service after one of the blizzards took down the cable. Their station was the farthest off shore and the most exposed of any lighthouse on the East Coast. Twenty-one miles out to sea was not a cozy place to be in the midst of a nor'easter or its aftermath, and in their exposed wood-frame house, the Beal family had to harden themselves to even more isolation and hard weather than usual.

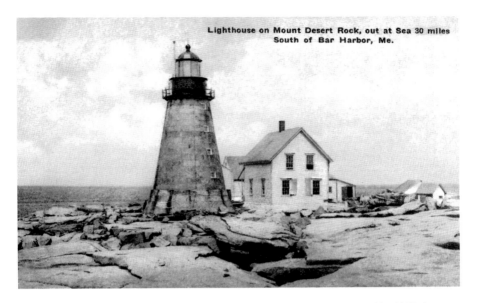

Lighthouse on Mount Desert Rock, out at Sea 30 miles South of Bar Harbor, Me.

The lighthouse on Mount Desert Rock, established in 1830 and automated in 1977, is now maintained by College of the Atlantic. *Courtesy of Jesup Memorial Library, Bar Harbor.*

Just two miles from Mount Desert, on Gott's Island, conditions were somewhat better. "Large fields of ice which drift by the island are getting to be a common sight," the correspondent wrote in mid-February, "but our mail carrier gets his regular trips, not missing a day this winter." Their rugged mailman, Berlin Gott, sometimes had to navigate around the ice chunks at sea in a rowboat, but he made sure mail got to his island three times a week.

Stories of navigating the ice chunks became common that winter, but none was more tragic than that of fourteen-year-old Shirley Galley. He was clamming along Bass Harbor with Charlie Dow when the boys jumped onto a strip of ice that gave way and sent them plunging into the icy water. Charlie managed to save himself and tried to save Shirley, but by the time Charlie was able to pull him from the frigid water, Shirley had frozen to death.

"The present winter on Mt. Desert is hanging on with a vengeance," reported the Northeast Harbor correspondent in mid-March. One of March's storms was so bad it even confounded Berlin Gott, who had somehow managed to get the mail to Gott's Island every day until that mid-March storm. The Gott's Island correspondent was forgiving of this one lapse, however, reporting that "we think we are rather fortunate, for some of our neighboring islands have been without mail for four days at a time." Despite the floating ice in the bay, Charles Harding and Frank Babbidge

had boated from Gott's to Duck Island to carry grain to the sheep. But meanwhile, the wood situation was getting worrisome. With no horse on Gott's Island, the men were accustomed to hauling their wood by hand sled in the winter, but the deep snow was making that impossible, and islanders had to ration what wood they had. Meanwhile, the men had put away their lobster traps for the season, but the bitter weather had not put an end to fishing, as their boats were now loaded with scallop gear.

At Mount Desert Rock, the March storm brought harsher winds than the Beal family had seen even in January. Mrs. Beal declared the storm of March 7 to be the "worst of the season," as the family hunkered down to wait out a sixty-mile-per-hour gale. "The sea was rising mountain high," she reported, "pounding against the boathouse until it seemed it would break the doors. Then the snow turned to sleet, freezing as fast as it struck." With Southwest Harbor frozen in since the first of February, no supplies had reached the Beals since, and the hens weren't laying. Although hard weather for lobstering, the keepers managed to get to their traps occasionally, but they only got lobsters enough to pay the mail boat. Food was scarce, but the Beals and their crew shared what they had.

Vinal Beal, 1925. *Courtesy of the Mount Desert Island Historical Society.*

"Owing to the severe winter there has been very few birds stay on the rock, in fact, only one English sparrow is left from the thousands that were here last fall," Mrs. Beal noted, "and he would have perished with the rest if the keepers had not left their sheds open for him to get into out of the cold, and left food for him to eat."

The birds were a concern to softhearted residents all

over the island. "One of the chief diversions of this ice-bound village for the past two weeks has been feeding the seagulls which have hovered over the town constantly, looking for something to satisfy their hunger," wrote the correspondent from Southwest Harbor. With every inch of the shore covered in ice, the birds' usual supply of shellfish was gone, and they were desperate for food to fuel themselves in the frigid temperatures. Residents would scatter table scraps in their yards, and in a few minutes, dozens of the great gray birds would appear, squawking and fighting over the food. The black ducks were suffering, too, with their feeding grounds over the flats covered by ice. Ducks were starving to death, their corpses littering shorelines until residents began scattering corn to help keep the remainder alive. Even the beginning of April brought no sign of spring and four feet of snow still covered most of Mount Desert Island. Even the old-timers didn't remember anything like it.

The snow was a boon to the new ski industry, however. The first international Winter Olympics was a year away, and ski resorts were beginning to pop up in the West. Locally, the steady supply of fresh snow inspired many Bar Harborites to take on the growing sport. On Sunday afternoons between storms, crowds flocked to Bunker Hill ski slope at Kebo Valley for skiing as well as tobogganing.

The weather cleared long enough for hundreds to attend Bar Harbor's Winter Carnival in February. "Nothing could better demonstrate the joys of winter life in Bar Harbor," wrote Sherman. Enjoying their winter sports like never before, Bar Harborites began to think maybe their island had the potential to become a year-round destination. "The prediction was

A frozen-over Mount Desert lake, circa 1920. *Courtesy Jesup Memorial Library, Bar Harbor.*

freely made both by residents and out-of-town visitors," said Sherman, "that within a few years Bar Harbor's fame as a winter sports center would rival its renown as a summer resort." Visitors traveled from all over Mount Desert and from all over Maine to join in or watch winter events, which included skating, ski-joring, ski jumping, ski and toboggan racing, ski hill climbing and snowshoeing.

Skating, the oldest of Bar Harbor's winter pastimes, was honored with competitions for boys and girls of all ages at the Athletic Field's Glenmary Pond. Heavy snows had meant limited time for practice in the weeks leading up to the carnival, but the pond was clear and ready for skaters the morning of the event. Spectators were also entertained by the fancy skating of Russ Jones, formerly of the New York Hippodrome, and marveled at his spectacular spins, whirls and jumps over orange crates.

The town's first ski-joring exhibition featured local resident Arthur Hellum displaying his skills, skiing along Mount Desert Street from Spring to Main. "Standing erect on his skis and apparently as much at ease as though he were in a sleigh," Sherman wrote, "he was drawn at a rapid rate by the fast-trotting horse that he drove."

After the skating and ski-joring events, most of the spectators walked across the Malvern Gardens and up Morrell Drive to the snow-covered slopes of Bunker Hill. Here Bar Harbor could show off the new ski jump, seventy-five feet back from the brow of the hill and twenty-five feet high, along with its new five-hundred-foot toboggan shoot. Dozens of events kept participants and spectators busy until sunset, when the action again turned to the village, with a program at the casino on Cottage Street. As a packed crowd settled in for the evening, Bar Harbor resident and former circus performer Bobby Mainfort performed a ring and trapeze act that included his wife and Miss Johnston in a swing suspended by Mainfort's teeth. Next was toe dancing and singing by little Eleanor Fielding, and then George Renwick, a tenor with the Harvard Musical Clubs, sang a solo. Mainfort returned to the stage for a wrestling match against Chester Kennedy of Bangor, who outweighed him by thirty-five pounds. Mainfort must have been tired after his earlier performance, but he still managed to keep Kennedy on the defensive for about a half hour before losing the first round. He fell more quickly in the second, losing the match. Winners of daytime events were awarded prizes, and the crowd ended their long day by dancing the night away to Moore's orchestra.

During the carnival, organizers showed a moving picture of winter sports at Poland Springs, another Maine resort area getting into the winter sports

business. Inspired by the movie, the board of trade hired the Fox Film Company from Bangor to take moving pictures of local winter sports, and it seemed that all Bar Harbor turned out to be part of the production.

It was the sort of winter that made residents note with surety the first spring-like day. All were in agreement that it arrived on April 6 with the women's clubs' traveling art exhibit, a great inspiration for housewives to begin their spring cleaning: curtain materials, draperies, portieres, antique and modern table covers, handcrafted linens and floor coverings were on display to encourage their springtime desires to redecorate.

Warm sunshine and longer days began to penetrate the snow on Mount Desert Island, but it wasn't until mid-April that the first automobile got through to Ellsworth and the road to Otter Cliffs was finally broken out thanks to efforts of twenty-five men from the station working for two days to attack the worst of the drifts.

The receding snow revealed a battered town unfit for the summer colonists. Town officials deemed the Village Green "little short of disgraceful," and in places along the ravaged Shore Path, the sea wall had fallen in. Summer people on the Path Committee met in New York City to discuss the damage done to paths all over the island due to the severity of winter weather and noted that they would need more work than usual.

Residents freshened their own houses with paint and got work painting, repairing and opening the houses of the summer residents in preparation for their return. Locals dug into their gardens as soon as they could and worked feverishly on the landscaping projects of the summer colonists, hoping those from away would understand that the late spring had caused the delays.

As the earliest of the summer residents began to arrive, year-round people, too, began to turn their thoughts to social and warm-weather pursuits. In the first real competition of the season at Kebo Valley golf course, the post office team won three of out of five matches against the businessmen's team. Marnel Beal and his sister left Mount Desert Rock to stay at Manset for the spring term of school. Getting off Gott's Island became easier and being on the water, even at night, got warmer. Gott's Islanders were again crossing Bass Harbor Bar to attend the moving pictures at Reed's Hall in McKinley on Saturday nights.

"Many rare birds are seen about town," wrote the correspondent from Southwest Harbor with enthusiasm. "Flocks of horned larks are frequently seen and the sparrows of many different kinds seem unusually plentiful. The old saying is that 'many spring birds means a full crop of fruits and berries.' We hope it proves true."

4

THE RUM RING

In the early 1920s, a few of Mount Desert Island's local residents became very wealthy despite their seemingly ordinary jobs as saloonkeepers, boardinghouse managers or retail shop owners. They owned fleets of Roadsters and the latest, fastest boats powered by automobile engines. Other island men seemed to be at their bidding, serving as drivers for their bosses, who always seemed to have an unusual number of "errands" that needed running. Hired hands constantly motored their bosses' vehicles off island to Bangor, Augusta and beyond or sped their powerboats out of MDI harbors at odd times of the night. Most islanders looked the other way, but they knew illegal liquor was concealed in those Roadsters and in those boats with painted-over names.

The advent of the National Prohibition Act of 1920 didn't alter prohibition laws in Bar Harbor. Making, selling and transporting alcohol had been illegal for seventy years already in Maine. Visitors to Bar Harbor had adjusted to Maine's very conservative approach to liquor consumption long before 1920, whether that meant learning how to do without, how to get around the law or how to defy it without getting caught. So when the rest of the country went dry, life in Bar Harbor seemed to go on as before. The saloons had never openly served alcohol, dances at the casino had never publicly included liquor and social gatherings at the Swimming Club had always been dry, according to official record. The radical change experienced elsewhere in the country in 1920 had happened in Bar Harbor in 1851. For decades, anyone who brought liquor into the state of Maine for the purpose

Mount Desert Bridge, 1923. *Courtesy of the Mount Desert Island Historical Society.*

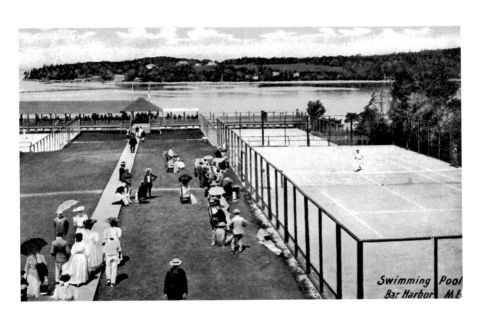

Swimming Club (postmark 1911), circa 1903. *Courtesy of Jesup Memorial Library.*

of resale had smuggled it in. Often the best way to do this was by water, and so the "rumrunners" frequented the Maine coast. MDI, with its many harbors, islands and coves, as well as its many thirsty summer visitors, had been popular with smugglers of liquor for decades.

For Bar Harbor's enterprising rumrunners, the National Prohibition Act, also called the Volstead Act, was the greatest boon to business they could ever wish to see. Bar Harbor was already home to seasoned smugglers by the time the rest of the country caught up with Maine's anti-liquor law. This gave some enterprising Bar Harborites a couple advantages as America roared into the 1920s. They already had their network in place, a network that included important contacts in Canada and the Caribbean, with operators who had experience functioning under the radar of the law. Suddenly, customers from out-of-state were looking for the liquor the Bar Harbor boys already knew how to supply.

At the center of Bar Harbor's black market liquor trade stood Daniel Herlihy, an Irish Catholic rogue from Bangor whose combination of street smarts, charm, leadership ability and ambition had propelled him into the kingpin position over Bar Harbor's enterprising underground businessmen. Danny was a likeable man with black hair, sparkling dark eyes and a ready smile. His family had migrated from Bangor to Bar Harbor to establish themselves in the saloon business in the 1890s when Danny was a rebellious young man in his twenties. In those days, he was frequently in trouble with the law, paying fines for selling liquor or getting himself off the hook on technicalities. The Herlihy family's downtown establishment thrived in the summer with the influx of both tourists and the hired help who arrived with the wealthy rusticators.

Around the turn of the century, when Maine was at the forefront of the prohibition movement, Herlihy always seemed to be at the center of the underground resistance: on trial for "keeping intoxicating liquors intended for illegal sale" or for "keeping a common nuisance," scolded for keeping his Woodbine Club open past 10:00 p.m, praised for pointing a finger at the grand hotels for committing the same crimes for which he was accused. In 1905, when police raided Herlihy's establishment, a large crowd followed them in, openly jeering at the officers as they seized a basketful of liquor and three slot machines.

Herlihy persisted in his illegal activities, learning how to beguile not only the easily charmed Democrats in public office but the more conservative Republicans as well. After his father passed away and his brothers moved on, Danny became the undisputed king of the rum game in Bar Harbor and also controlled the lucrative boxing events. No one else dared to promote a boxing match knowing that they weren't allowed to pull off so much as a three-round go with ten-pound pillows for gloves unless they were working for Herlihy. He was a good boss, friendly and encouraging as long as he

was happy with the work. But he expected his orders to be obeyed, and he expected unquestioning loyalty to his operation. For decades in Bar Harbor that's just what he got.

Meanwhile Herlihy's private life was just as dramatic as his black market business dealings. His divorce from the lively Belle Higgins (she accused him of adultery) caused quite a stir in the early 1890s. Tongues kept wagging when it appeared that he continued, at least part of the time, to live with Belle and their son, Walker, for years after the divorce. Yet no one could have predicted the next chapter in Dan Herlihy's love life.

In the summer of 1913, now well established in his "trade," he appeared to be spending time with Dr. Ada Bearse. Serious and determined, she had gone to medical school when few women ever thought about rising above the ranks of nursing. After graduating from the Massachusetts College of Osteopathy, she had established herself as a physician in Boston. Professional and well connected through her Beacon Street family, she seemed a highly unlikely match for a rake like Herlihy. In October, the news was out that the affluent, independent physician was building a house near her sister on Livingston Road in Bar Harbor. Rumors were flying now, and sure enough, the following June, smuggler Daniel Herlihy, he of the obscure Irish Catholic background and a long list of legal infractions and domestic scandals, married the wealthy, professional, upstanding and progressive Ada Bearse. Bar Harborites were perplexed as to what these two middle-aged people (she was forty-four and he forty-six when they married), so established in their own very different worlds, could possibly have in common. And yet, they seemed to delight in each other's company.

More amazing yet, his marriage to the upper-class Bearse did not slow Herlihy down one bit. Rather than retire to a life of leisure and refinement, he continued to live in a world of illegal contraband. Herlihy and the Rum Ring thrived in the early '20s, unloading their illegal cargoes by night on the rocky shores of Mount Desert and outlying islands, storing it in unoccupied summer homes or even downtown Bar Harbor businesses and selling it at a profit to buyers all over New England. The entire country's liquor trade was now underground, and thanks to his years of business in teetotaling Maine, Herlihy knew how to run an illicit operation.

In 1920, Herlihy was poised to defy the Volstead Act. It fell to enforcers of the law to catch up with him. No federal Prohibition agent was assigned to Mount Desert Island, but Coast Guard and customs service officials were authorized to enforce the national law. This meant a new and important role for Howe Higgins, who took the position of deputy collector of customs

in Southwest Harbor in 1920. Not all U.S. customs officers were eager to enforce the new liquor law, but Higgins took his job seriously, even zealously. Once deputized, he spent countless nights staking out remote coves and inlets on Mount Desert Island, waiting patiently for the arrival of a powerboat laden with liquor from some offshore steamer.

In 1922, he wrote a letter to his fellow customs collectors warning them about some of Mount Desert Island's biggest rumrunners. He made a drawing of a motorboat, owned by Clarence "Pettigrove." The name was really "Pettigrew," a mistake that would later catch up with him when the spelling error was the cause for dropping the charges, but in other ways, his report was accurate and detailed. "Am sending this information along for what it is worth," he added, and in 1922, he probably wasn't sure it was worth much.

The report, like most before it, was widely ignored. Everyone in customs knew Herlihy had the law enforcement boys in his back pocket. Even when Higgins managed to come up with a good lead or solid evidence, Sheriff Wescott and the municipal judges chose to look the other way. The sheriff's department would not follow through on Higgins's information, or the culprits charged with customs violations would get off on a technicality. One way or another, Higgins's efforts would not end in prosecution, and Herlihy's boys would wriggle out from under the law. But Higgins was a fly in the ointment, and rumor had it Herlihy had a contract out on him for $500.

Then, at the beginning of 1923, Higgins found some new support when Percival Baxter was inaugurated governor of Maine. Baxter promised to "stimulate some of our officials to greater efforts" when it came to enforcing the Prohibition law. "Our sheriffs, county attorneys, local judges, and municipal police, if their hearts are in their work, can drive or imprison the whole brood of liquor offenders," claimed Baxter in his first address as governor. Higgins couldn't have agreed more; his heart was most definitely in his work.

That winter Higgins managed to make contact with a disgruntled former employee of Herlihy's. The mutinous ex-driver tipped Higgins off about a haul stored in a Bar Harbor garage owned by George McKay on Main Street. A member of the board of trade and Knights of Columbus, McKay had long been suspected as one of Herlihy's high-level associates. With assurances from the Baxter administration that convictions would follow, Higgins got a search warrant based on suspicion that the liquor had been brought into the country illegally, making the offense a customs violation. In March, Higgins searched George McKay's garage and found a stash

hidden in a large wooden tank: 52 cases of assorted liquor (570 bottles) and one keg of rum smuggled into the country from the Danish West Indies via Barbados. But Higgins was just getting started. Later that week, he seized an additional 250 cases of high-grade Scotch whiskey, rye and gin from the home of Malvern Greenhouse owner John Stalford. Bar Harbor had never seen seizures like this before.

During the same week, in an unrelated trial, the defense attorney asked Deputy Sheriff George Clark if he had been "active" in enforcing the probationary laws. "No I have not, and you know it," answered Clark. A week later, Clark was suddenly taking the offensive himself, traveling around the island by boat to Mansett to seize nearly six hundred gallons of genuine Vera Cruz rum at a retail value of $10,000. A crowd gathered at the Maine Central Wharf to watch Clark and his assistants unload their cargo and haul it on a two-horse sled to the rum locker at the Bar Harbor police station. The fact Clark of Bar Harbor had seized liquor in Southwest Harbor after Higgins from Southwest Harbor had seized liquor in Bar Harbor was not lost on the crowd, and the word "retaliation" might have slipped through their lips.

More raids followed, but sometimes, the Rum Ring was still able to outsmart the law. In April, the feds tried to get involved when Chief Jack of the Federal Prohibition Enforcement Squad got a tip that four hundred cases of first-class gin and whiskey had been landed on Long Island, an outer island south of Mount Desert. Jack and his deputies had to break through thick ice to get to Long Island, and that gave the smugglers plenty of time to see them coming. They hauled four hundred cases of liquor from their hiding place in the haymow of an old barn and, using a different route freer of ice, safely got back to MDI to stash the contraband somewhere else. When the feds finally got to Long Island, they found only six cases of gin. Worse yet, evening was closing in, and they were forced to stay overnight in the barn, cold and hungry, before returning to the mainland the next day nearly empty-handed.

But meanwhile, Higgins's seizure from McKay's garage in March was turning out to be the evidence the officer needed to cripple Herlihy's operations. In June, a federal grand jury indicted Herlihy, along with McKay and Stalford, on charges of violating the Volstead Act. They were released on bail, set for Herlihy at $5,000 (over $50,000 in today's money) and for the others at $2,500.

Others were indicted and arraigned in June thanks to Clark's efforts on the other side of the island. Derby Stanley was charged with conspiring to

violate the Volstead Act and released on $2,500 bail. Stanley had grown up in Southwest Harbor, where his mother ran the Stanley House and was active in the Woman's Christian Temperance Union. Her son, Derby, was a college graduate, having distinguished himself at Bowdoin as a star baseball player. But despite his mother's anti-liquor stance and his own upstanding reputation as a scholar and an athlete, folks around Southwest Harbor had always suspected that Stanley's fast auxiliary schooner, the *Kaduskak*, was used for more than just pleasure cruises. The captain of the schooner, Fred Hyman of St. Martin in the British West Indies, was under indictment as well but remained at large.

In August, all the respondents in the Bar Harbor Rum Syndicate indictments plead guilty to violating the Volstead Act when arraigned before Judge Peters in the U.S. District Court. Saying that he understood that they were out of the business and felt they would stay out, Peters only imposed $1,500 fines on Stanley and Stalford. Mckay had to serve a yearlong sentence in the Bangor jail. Peters reserved his harshest sentence for the Rum King. Saying that strict measures were necessary in order to remedy the lawless situation in Bar Harbor, he sent Herlihy to the Atlanta Penitentiary for one year.

The most powerful Rum Ring in Maine had been shut down, but Governor Baxter was not finished with Hancock County and its renegade ways. He persisted in pointing the finger at law enforcement officers who had looked the other way for years as the illegal liquor trade flourished. In October 1923, Baxter demanded the resignation of Sheriff Ward Wescott. When Wescott refused, he was ordered to appear before the Governor's Council in November. That appearance drew strong statewide attention and shed light on MDI's firmly entrenched smuggling business. Details long rumored and whispered on the island now spilled out of local citizens, Prohibitionists and bootleggers alike, as one after another testified in front of the Governor's Council. Many town leaders, including Judge Charles Pineo, testified that "drunkenness was common and little or nothing was done to stop it."

"Rum has been sold as freely as bread in Bar Harbor for years," claimed Pineo, "but since the Volstead Act in 1920 business has been wholesale."

The prosecution claimed that

> *Bar Harbor and adjoining towns had for a long time been the headquarters of a gang of lawbreakers who were open in their defiance of the law; that their illegal business was common knowledge in the community; that they imported, sold and transported liquor in large quantities without molestation*

by or fear of the sheriff or his deputies; that this went on for months and was only stopped when Daniel Herlihy and several others were caught by the federal officers, convicted and sentenced to various terms in federal and state prisons for their offense against the federal liquor laws."

Clifford Willey, promised protection by Governor Baxter, testified that he had formerly been in business with Herlihy. He said Herlihy did $200,000 to $300,000 worth of business each year (over $3 million in today's money). The liquor smuggled to the Maine coast was landed on various parts of Mount Desert Island and Blue Hill Bay, he explained, and the point of delivery would change with every cargo. From those points, it was delivered throughout Maine and other states in cargoes of 75 to 150 cases of twelve bottles each. Willey also said that Herlihy's Lenox Club was frequented by many Bar Harbor businessmen.

Temperance proponents also had their say in front of the Governor's Council and voiced their helplessness in the face of what they saw as obvious disregard for the law. Reverend J. Homer Nelson of the Bar Harbor Congregational Church testified that there was a dance hall in town called the Sink "where there was much drunkenness and vice."

Reverend William H. Patterson of the Episcopal Church said he never complained to federal authorities about the local liquor trade because he was told that "a complaint made to federal authorities usually found its way back to the party accused." A.D. Gray, superintendent of schools, said it seemed like the deputies were taking graft, but he couldn't prove it.

In the governor's effort to get at Wescott, George Clark, his Bar Harbor deputy, also came under fire. The prosecution contended that Deputy Clark "was not active or apparently much concerned about the enforcement of the prohibitory law." In fact, it contended, he frequented Herlihy's Lenox Club and "appeared to be on very friendly terms" with the staff and owner. He had purchased liquor there and carried it away. Westcott himself rarely showed up in Bar Harbor, they claimed, and didn't pay much attention to what Clark was or wasn't doing there.

Willy testified that the year before he had given Clark a tip that a boatload of rum was coming into Schooner Head, but Clark never did anything about it. Willey confirmed that Clark had been a regular at the Lenox. He had often seen the deputy there, most of the time relaxing with his feet up on a table.

When Wescott himself took his turn, the prosecutor asked him, "Why didn't you…put Herlihy out of business?"

Old liquor bottles. *From the collection of the Mount Desert Historical Society.*

"That idea is preposterous," Wescott replied. "You can't convict one of selling liquor without evidence…Herlihy didn't do any business himself. Others did it for him…I didn't take out a warrant to search Herlihy's place because I had reason to believe he didn't keep liquor in the place." Furthermore, said Wescott, the liquor was stored on the premises of some of the best people in Bar Harbor.

"Will you admit that Herlihy and his rum runners beat you on Mt. Desert Island?" Governor Baxter asked Wescott.

"I am sorry to admit it," Wescott replied.

The prosecution had only to prove that Wescott was "inefficient" in order to give the council reason to remove him from office. Governor Baxter and his brother, Senator Rupert Baxter, voted to convict Wescott, but the other six councilors voted to acquit him. Wescott was free to remain in office, a decision approved by most Hancock County residents, who resented the governor's meddling in their affairs. Thunderous applause greeted the announcement of his acquittal.

Wescott's reprieve didn't discourage Howe Higgins from his energetic pursuit of liquor violations. In November 1923, he managed to get a search warrant signed by municipal judge Pineo, who had only been in his position a few months, to search the Bar Harbor Banking & Trust Company for "any box, vault, trunk, barrel or other containers." The suspect of this search was a "person or persons unknown." Higgins knew that there was liquor in the vaults of the bank and assumed it had been brought into the country within the past few years, which meant a customs violation. What he found caused the Bar Harbor business community a huge amount of embarrassment not because the guilty party was one of their own but because the liquor was owned by some of the resort town's most prominent and wealthy summer people: diplomat Robert H. McCormick, Philadelphia high-brow Mary Cole and, worst of all, Mrs. Joseph Pulitzer of the famous publishing family. These were people the Bar Harbor business leaders wanted to make welcome and had no intention of harassing. Charging them with customs violations could only hurt the resort's reputation among those they most wanted to impress.

This time Higgins had gone too far. In the federal district court trial that took place the following June, he was soundly reprimanded by Judge John Peters, who ruled that Higgins's search warrant for smuggled goods didn't hold up in court because he had no evidence that the goods had been smuggled. In fact, the owners were willing to testify that all the liquor had been obtained prior to the enactment of the Volstead Act and not been smuggled at all. Judge Peters warned Higgins that searching premises "without probable cause" could lead to a prison sentence. The court also chided municipal judge Pineo, who had signed off on the search, warning that it was "a serious offense to invade a man's premises without proper warrants." Judge Peters ordered the illegal liquor returned to its owners.

That incident disposed of, the following day, the federal grand jury announced a number of new indictments against well-known Bar Harbor people, all seizures having been made by the relentless Howe Higgins. Summer resident Campbell Steward was indicted for importation and transportation of a mere four bottles of liquor. E.G. Grob, manager of the elite Malvern Hotel on Kebo Street, was indicted for importation and possession of thirty-eight bottles of liquor. William S. Moore, husband of Edith Pulitzer, was indicted for possession of a "large quantity" of liquor.

Worse yet was the indictment against Mrs. DeWitt Cuyler, widow of one the most generous and well-liked members of the summer colony. Before his sudden death in 1922, Cuyler had been director of the Pennsylvania

Newport House and the Shore Path (mislabled on the postcard due to a misunderstanding of the Downeast accent). The Newport House was located just south of Agamont Park and was demolished in 1938. Photograph circa 1900. *Courtesy of Jesup Memorial Library.*

Railroad, and his influence in Bar Harbor had been extensive. He owned the Malvern Hotel, and after his aunt Marie DeWitt Jesup donated the money for the Jesup Memorial Library, he helped oversee its construction. His funds and fundraising efforts also had helped to build the additional nine holes at Kebo Valley; he had been president of the Pot and Kettle Club and on the executive committee for the Bar Harbor Water Company. To indict Mrs. DeWitt Cuyler of Stonecliff on Kebo Street for the importation and possession of forty-three bottles of liquor was unthinkable. Anyone whose livelihood depended on the goodwill and continued patronage of the island's summer people were livid about how their best customers were being treated, but Howe Higgins was feeling good about a job well done.

However, in February of the following year, William Moore won a victory in district court when Judge Peters ruled that once again Higgins had unlawfully obtained a search warrant. Judge Peters ruled that under the National Prohibition Act, a search warrant could not be obtained to search a private dwelling unless the place was being used for the sale of intoxicating liquor. When Higgins seized the liquor from Moore's caretaker's house at Woodlands, he had no reason to think Moore intended to resell

the liquor. The indictment was quashed, and Moore was off the hook. The other indictments never led to prosecution.

The frenzy caused by the Rum Ring's spiraling power over the island and the government's decisive retaliation wound down after Herlihy was sent to prison and Higgins had gotten his hand slapped a couple times. In 1924, when Danny Herlihy got out of the pen, he was not yet ready to return to the scene of his crimes. Instead, he and Ada embarked on a six-month cruise around the world. But Herlihy would return. The Roaring Twenties weren't over yet, and he was far from done showing Bar Harbor a good time.

5
THE GREAT DIRIGIBLE

On a July day in 1925, eager spectators sat in boats anchored in the harbor, crowded the Shore Path and wharves, stood on downtown rooftops and thrust their heads out of store windows, everyone gazing upward into the pale blue evening sky. As the sun disappeared below the water's horizon, it was replaced by a giant gray airship that glided silently into view. It grew bigger and bigger as it neared and then hovered over the thousands of faces turned upward in amazement. At 680 feet long, longer than a block of West Street, the *Shenandoah* was somehow, impossibly, floating in the sky. "The arrival of the great dirigible," Albion Sherman wrote, "was the most eagerly anticipated event within the memory of anyone in Bar Harbor." The airship seemed larger than life and yet elegant in its progression. "Something there was of majesty in that coming," said Sherman. As the great airship tied up to its mooring mast on the mother ship *Patoka*, the harbor erupted in noise as three U.S. Coast Guard destroyers blasted their horns and others on watercraft blew their whistles.

Nobody in the crowd of onlookers was more fascinated with this airborne machine than Alexander Wilson. Then in his seventies, Wilson had always been intrigued by flying contraptions of any kind. When the *Shenandoah* visited, he was working on a flapping wing airship of his own design. An inventor and adventurer, the Bar Harbor resident had been one of the pioneers of parachute jumping and then went on to design and pilot a glider that took off from a frozen lake on Mount Desert Island and flew halfway up the mountain before landing again successfully. He had created a device

The Shore Path in Bar Harbor, circa 1921. *Courtesy of Jesup Memorial Library, Bar Harbor.*

to harness energy from the tides for which he tried but failed to obtain a patent. He did, however, receive a patent on an invention that conserved fuel by harnessing the energy from pedestrian footsteps to generate power for a hydraulic engine. The invention was tested by a big New York City hotel but failed to catch on.

As most of the crowd stood in awe of the giant in the sky, Wilson gazed with an analytical eye on the dirigible. First flown two years before, the *Shenandoah* was the first of four rigid airships built by the U.S. Navy. It was fueled with a lifting gas called "helium," so rare at the time that the airship contained most of the world's supply. The navy had intended to use the new invention for military observation, but its susceptibility to foul weather was making the airship less practical than hoped. Maintenance and testing had kept the dirigible grounded for the first half of 1925, and now the airship was staying busier with public appearances than with reconnaissance missions. On its way to Bar Harbor from Lakehurst, New Jersey, it had hovered over President Coolidge giving a speech in Cambridge, Massachusetts, before flying on to Frenchman's Bay to become part of Bar Harbor's Independence Day celebrations.

Bar Harbor was playing host not only to the phenomenal airship but also to a group of U.S. governors fresh from their annual conference held that year at the Poland Springs Resort in Western Maine. Among the

Docks at Bar Harbor, circa 1910. *Courtesy of Jesup Memorial Library, Bar Harbor.*

distinguished visitors was Nellie Tayloe Ross of Wyoming, the country's first female governor, who had succeeded her husband when he died in office in 1924, and the notorious Edward Jackson of Indiana, a former member of the Ku Klux Klan. After the official conference ended, fourteen of the nation's governors stayed on in Maine to take a tour of the state.

Just as the appearance of the airship attracted a crowd of hundreds, so had the arrival of the governors earlier in the day. At the ferry terminal downtown, well-wishers cheered as the dignitaries arrived on the *Norumbega*. The ferry blew three sharp whistles, and the destroyers in the harbor gave a seventeen-gun salute while on shore, the Bar Harbor Band played marching tunes to welcome the dignitaries. Under the direction of summer resident Walter Damrosch, conductor of the New York Symphony Orchestra, local schoolchildren sang "America." A few months later, Damrosch would make news for conducting the world premiere of George Gershwin's *Piano Concerto in F*, but for now, his full attention was on the voices of Bar Harbor's young children. Boy Scouts waved their banners. Kindergartners scattered daisies in the path of the governors. The celebrities were escorted to waiting Packard Roadsters and, led by parade marshal and summer colonist Philip Livingston atop his champion steeds, were driven through town to the Malvern Hotel on Kebo Street.

Walter Damrosch, conductor, 1908. *Courtesy of Wikimedia Commons.*

Bar Harbor Pier and Waterfront, circa 1930. *Courtesy of Boston Public Library.*

The events of the day had been carefully planned by an entertainment committee that boasted an unusual mix of both Bar Harbor summer residents and town business leaders. Morning activities for the governors and their entourages included a choice of golfing, sailing, boating on power yachts or touring the island by automobile. At noon, the entire group reconvened at the summer colony's exclusive and intentionally rustic Pot and Kettle Club above Hulls Cove on Shore Drive. Under brilliantly blue summer skies, a band played familiar tunes as guests dined outdoors and gazed on Frenchman's Bay.

The afternoon included a stop at Jordan Pond House, where the group sipped tea on the verandah, gazing across the lawns toward the pond and the bubbles in the distance. The grand tour continued with stops at the Ford and Rockefeller estates and then more tea at the home of socialite Susan Whitney Dimrock before returning to the hotel in time to dress formally for the evening affairs.

Dinner was at the Malvern Hotel to the strains of Dodge's orchestra. And even after the day full of eating and touring and meeting and greeting, the festivities were far from over. The dignitaries were then escorted to the Swimming Club for a formal ball, yet another supper served at midnight and then more dancing before Governors' Day in Bar Harbor finally came to an official end in the early hours of the morning.

On Saturday, the Fourth of July, Bar Harbor played host to one of its largest crowds ever for the annual Legion parade. The governors, Captain Lansdowne and others from the crew of the *Shenandoah* watched with the crowds as well-drilled sailors from the Coast Guard destroyers marched by with impressive precision. Behind the marchers came the promotional floats. The First National Bank seemed to glide by spectators in the form of a float designed to look like the downtown building. The Clark Coal Company float featured sacks of coal, and the Ford truck from the F.J. Brewer Electrical Company was decorated in majestic colors of gold, purple and lavender. Amid the regal colors sat a breakfast table displaying the latest in household electrical appliances. Next came the automobiles, among them Buick coaches, Nash sedans and Packard Straight Eights, and then trailing behind them was a lone horse-drawn carriage. Most onlookers could remember when the horse-drawn entries had dominated their local parade, but in 1925, only Harold Whitney's chariot, pulled by horses from the Foley stables, harkened back to old times.

That afternoon, the Shenandoah was again the center of attention when the governors of Oklahoma, Delaware and Virginia took an hour-long

ride above the bays. The dirigible made national news on this trip when Commander Lansdowne broke the world record for the time it took for mooring upon its return to harbor. The dirigible did not land on land or sea but remained floating in air when at rest. In order to stay in one place, it needed to attach itself to the top of the tall mast of the mother ship, the *Patoka*, and did this when both ships were moving. This difficult maneuver was accomplished in only eighteen minutes in Bar Harbor, shattering the former record of thirty-two minutes.

After its spectacular visit, the *Shenandoah* left Bar Harbor for a stop in Camden and many more publicity events on its calendar. Tragically, two months after their memorable Fourth of July celebration, Bar Harbor citizens were shocked and dismayed to hear that the *Shenandoah* had crashed, exploding over Ohio after encountering a violent updraft during a thunderstorm. The ship was torn into pieces, killing fourteen members of the crew, including Commander Lansdowne. Amazingly, twenty-nine people survived the crash, riding sections of the airship to the ground.

Those who had recently seen the majestic ship aloft over Frenchman's Bay on a beautiful summer evening found it hard to believe its tragic fate. However, Alexander Wilson might have been less shocked than most. "I have been aloft many times with gas and I know its power...I know also some of the wind freaks, and man has a lot to learn," said Wilson after hearing the news. And yet the adventurer was not at all critical of the airship or those involved with it. "My sympathy is to men who do things and fail," he said, "and I will take my hat off to those who try."

6
THE ROGUE WAVE

Lobsterman Maynard Torrey was in his boat between Little Gott and Black Islands on a gray January day in 1926. A bit of snow had fallen on this Saturday morning, but the winds were calm and the weather as cold and dreary as usual in January. Then, quite suddenly, Torrey realized his world had changed in ways he could actually see but found hard to believe.

Off Black Island was a submerged granite ledge. Although always under water, every lobsterman who set traps knew it was there. But now Torrey, alone in his wooden dingy in this spot he knew so well, found himself gazing at the ledge, no longer under water but exposed to the cold January air. Torrey was getting a good look at this when it struck him that the wall of rock was moving closer. "I thought the ledge was coming at me," Torrey recalled later. "And then I realized my boat was being swept with mighty force right at that ledge."

On MDI, in the village of Bass Harbor, residents heard a rumbling sound coming from the direction of the waterfront, a sound odd enough to pull women and children from their houses and men from their fishing nets to investigate. Many got to the piers in time to see the ice violently shatter as their long narrow harbor emptied of water in one huge rush. Multi-ton lobster cars from the Underwood Canning Company were getting sucked out to sea. The water roared like a waterfall as it funneled its way out between the ledges, leaving portions of the harbor sucked dry.

Chester Sawyer and Forrest Albee were anchored in a dory floating in ten feet of water near the village when suddenly they found themselves on land

McKinley. *Courtesy of Jesup Memorial Library, Bar Harbor.*

not sea. Unaccountably stranded, Sawyer and Albee fled from their vessel and ran for higher ground, dodging the ice chunks that now littered the exposed harbor bottom.

Then just as suddenly came the surge.

Just as Torrey was about to crash onto the exposed ledge a great wave rolled over it, thrusting his small wooden boat away from the danger.

The wall of water rushed back into the harbor, ripping fishing boats from their moorings and returning the lobster cars that had been sucked away. Bass Harbor residents stared in awe as the oncoming waters broke the seventy-foot fishing boat *Fish Hawk* from its lines at the Underwood dock and crashed it against the pilings.

From a distance, Green Island fishermen got a view of the wall of water, about eight feet high, as it rolled back in.

At Bass Harbor, spectators observed two more waves, each smaller echoes of the first. As the spectacle continued, a series of great whirlpools followed in the wake of the waves, wreaking more havoc with the moored fishing boats, throwing some up on the flats and wrecking them completely, the entire harbor becoming a mass of foam as the water swirled.

The entire spectacle lasted less than an hour before the harbor was back to normal, and villagers were left to look at one another and shake their heads in wonder.

The Bass Harbor Head Light was built in 1858. *Pen and ink by Sara Tarbox.*

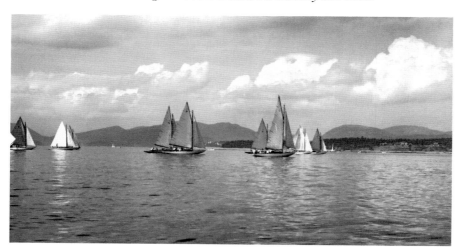

Sailboats in Northeast Harbor, circa 1929. *Courtesy of Great Harbor Maritime Museum, Northeast Harbor.*

By Sunday, news of the phenomenon had traveled up and down the coast. As reporters and curiosity seekers descended on the little village of Bass Harbor, scientists began to weigh in with theories. It was a bore tide, contended Dr. L.H. Merrill from the University of Maine.

This was no mere bore tide, countered those who had witnessed the event, not like ones they had seen before or after a heavy wind or storm at sea.

Gradually, a new theory began to take hold. The incident had been caused by an earthquake somewhere at sea. But scientists reported no seismic disturbances off the coast of Maine, so that theory, too, had its weaknesses.

In more recent years, scientists have contended that the cause was not an earthquake but an underwater landslide. The result was what the *Bar Harbor Times* labeled a "Rogue Wave" and others called a tidal wave. Today, we would refer to the strange phenomenon at Bass Harbor as a tsunami.

The wave appeared to be about a quarter of a mile long, and it caught the attention of residents of Southwest Harbor and Northeast Harbor as well. Residents in Southwest Harbor reported a series of four waves, each about five feet high, powerful enough to break many moorings and overturn many lobster cars.

Bass Harbor seemed to be the epicenter of the event, yet the villagers felt more grateful than persecuted. Although "it seemed as if the whole body of

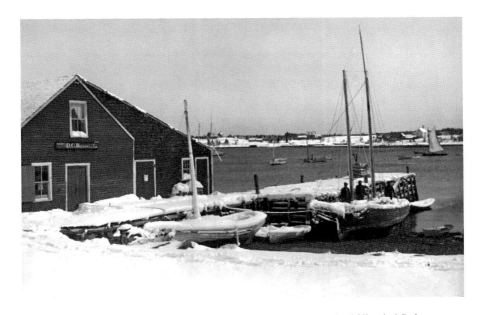

The village of McKinley, circa 1900. *Courtesy of the Mount Desert Island Historical Society.*

the bay moved," according to eyewitness E.L. Kelly, no one had drowned. The event had happened at low tide, and one didn't have to be a scientist to know how much worse the damage would have been had the wave randomly come at high tide.

The people of Bass Harbor were island people, used to the power of the sea. To be in a small wooden boat far from shore was to feel vulnerable, and yet fishermen like Maynard Torrey struck out into the ocean each day of their lives without fear. Perhaps that is why the people of Bass Harbor confronted their tsunami not with panic but with their usual Downeast reserve. A journalist visiting the village in the wake of the event reported with surprise that among the witnesses in Bass Harbor "the entire happening…seems to have been fraught with something of awe and with nothing even remotely akin to fear."

7
Mountainous Wealth and Quiet Living

On a day in mid-July, most often the eleventh, the steamer *Norumbega* would take an especially long time to disembark on its Seal Harbor stop. Slowly exiting the public ferry would be an army of nurses, tutors, secretaries, valets, kitchen maids, parlor maids and chambermaids. And then would come the grooms with a stable of horses and carriages, not to mention the family they served: John D. Rockefeller Jr.; his wife, Abby; and their six children. Their arrival in Seal Harbor would mark the end of a journey that had begun the afternoon before when the entire entourage boarded the Bar Harbor Express in New York City. Son David Rockefeller recalls waking in the train car in the morning to find "as if by magic we would be passing by the sparkling blue waters along the rugged coast of Maine." Arriving at the Mount Desert Ferry on the mainland at Hancock Point, the children would "climb down excitedly from the car when it arrived…breathing in the balsam-scented Maine air and pointing to Cadillac Mountain looming in the distance." From Hancock Point, the family would board the *Norumbega*. Four hours later, after a stop at Bar Harbor, they would arrive at Seal Harbor to begin their summer vacation.

Rockefeller, patriarch and industrialist, the only son of the Standard Oil founder and self-made tycoon, first stayed in Bar Harbor at Sears Cottage on the Shore Path in 1908. John and Abby's third child, Nelson, was born there. On Mount Desert Island, Rockefeller found a quiet haven, a welcome contrast to life in New York City, where he divided his time between his nine-story mansion on West Fifty-fourth Street and his office in the Standard Oil building on

John D. Rockefeller Jr., 1915. *Courtesy of Wikimedia Commons.*

Broadway. He identified in the local population a temperament similar to his own. Rockefeller was a quiet man, some said stern, and a harder worker than he needed to be, given his tremendous inheritance. He had a very private nature as well, and on the island, he was left alone, the local population being used to multimillionaire business magnates and never quick to intrude. Two years after first summering on the island, the Rockefellers purchased their own cottage.

They settled on the Eyrie, a half-timbered Normandy-style house on Bar Hill above the village of Seal Harbor. The Rockefellers proceeded to enlarge the mansion until it was a rambling structure full of steeply peaked gables rising from atop the hill. When he purchased his Mount Desert Island retreat, Rockefeller was thirty-six years old and the father of four children (with two more to come). In the same year that he bought the Eyrie, he also resigned from his directorship of Standard Oil Company, in an effort, he said, to "purify" his ongoing philanthropy.

Rockefeller settled into summer life in Seal Harbor in his own work-oriented way. His devotion to philanthropy was not just a full-time job but more of a 'round-the-clock calling. He rarely indulged in recreational activities but was usually found attending to correspondence or studying one of his countless files of information on one of his innumerable projects. He supported the restoration of Colonial Williamsburg and contributed to the League of Nations to build a library in Geneva. He financed the Bureau of Social Hygiene to fight venereal disease and contributed to activist Margaret Sanger's American Birth Control League; he financed the International Education Board supporting universities and research centers, donated key properties to Grand Teton National Park and added important medieval

The Eyrie, summer home of John D. Rockefeller Jr., circa 1930. *Courtesy of Boston Public Library.*

collections to the Metropolitan Museum of Art. In all these projects and more, Rockefeller took an active interest, contributing a perfectionist's love of detail to each one.

From his office at the Seal Harbor estate, he could at once be at work on his never-ending files of correspondence and in tune with the comings and goings of his active family of five boys and one girl. He relished the anonymity he had in Seal Harbor compared to New York City. He didn't even mind when a local laborer, delivering a grand piano to the Eyrie, mistook him for one of the help. "Give us hand," commanded the furniture mover, and JDR Jr. eagerly obliged. In fact, the incident was so unusual for him but, at the same time, so compatible with his own work ethic that he delighted in the experience and enjoyed retelling the story.

The senior Rockefeller occasionally visited his son at his summer cottage, and the patriarch made news on his first visit when he arrived in modern style: not by ferry but in a caravan of cars. "The party came through Saturday in five automobiles from Poland Spring where they spent Friday night," reported Albion Sherman in the *Bar Harbor Times* in 1919. "They have motored the whole way from the New York estate at Pocantico Hills where JDR celebrated his 80th birthday." Perhaps automobile travel at the time seemed too rustic for women and children because Abby and the young ones had taken the traditional route by train and then ferry. Rockefeller Sr. had never been to the Pinetree State before, and "he expressed himself as much pleased with the scenery all through Maine and particularly with

Mr. R.'s place in Seal Harbor." Sherman also noted that the octogenarian attributed his good health to a daily spoonful of olive oil and to golf. He was expected to play often at Kebo Valley during his stay.

In 1925, JDR Jr.'s eldest child and only daughter, named after her mother but usually called Babs, married her Seal Harbor summer neighbor and family friend David Milton, a lawyer and investment banker. Nelson's Mount Desert summer romance also blossomed into marriage. In 1929, he became engaged to Mary Todhunter Clark. "The engagement is said to be the sequel of a romance which had its origin at Northeast Harbor where the Clark and Rockefeller families had summer homes," the Northeast Harbor correspondent proudly noted. The couple married in 1930 and spent the first two weeks of their honeymoon in Seal Harbor.

Younger son David was more interested in beetles and worms than in romance and delighted in the Nature Study camps taught by biologist Helen Neal at the Harpswell Laboratory at Salisbury Cove. Her nature camp was popular with not only David Rockefeller but also young Henry Ford and many other summer colony children. They would be driven to camp, often by the family chauffeur in their Rolls Royces or Willys-Knights, two afternoons a week. At Salisbury Cove, they explored nature with Mrs. Neal, who helped them net and dig up squirmy, wiggly creatures and inspired the young rusticators to get excited about the natural world.

When the Rockefellers had first begun to enlarge their summer home, they retained Seal Harbor resident Byron Candage and his son Arthur to do the masonry. While working on the project in 1916, forty-seven-year-old Arthur succumbed to pneumonia, leaving his wife, Meda, a widow. The Rockefellers were touched by Meda's plight and took her into their employment. Meda never remarried and devoted her career to the Rockefellers, working for them not only during summers in Maine but sometimes moving with them year-round from their homes in New York City to Pocantico Hills, New York. Meda became something of a celebrity herself in her hometown, sharing her stories of working in the service of the Rockefeller family when she returned with them during the summer. She once gave a presentation at the Women's Literary Club about Egyptian antiquities that included pictures of locations recently visited by the Rockefellers on their Egyptian tour. Abby Rockefeller herself couldn't be there but sent a bouquet of red carnations for the festivities.

As Sieur de Monts National Monument grew into Lafayette National Park, Rockefeller took a strong interest in the park's development, from architecture to landscaping, forestry and roads. Because he was a perfectionist, he liked

getting in on a project at the beginning so he could do things his own way. He loved road building especially and had a great talent for engineering. He took pleasure in designing carriage roads that would be free from motorcars. He began with one near his home on the southern portion of the island and, through the 1920s and 1930s, expanded the web of motor-less roadways to all parts of the park.

One of the few sources of entertainment JDR Jr. would allow himself was horseback and carriage riding. Even though his family's unprecedented wealth had been made as the result of the world's sudden demand for oil to fuel the newly invented automobile, Rockefeller escaped from the world of motorcars when he could. He much preferred the quiet of a carriage ride and the clip-clop of a horse to the roar of a motor. In fact, escaping the motorcar had been one of his original incentives for summering in Seal Harbor. "One of the things which attracted Mrs. Rockefeller and me most to Mount Desert Island some twenty years ago was that there were no motors on the island," he said in 1928. "I greatly deplored the pressure to open island roads to motors and was one of those who opposed their admission to the last…I am interested in automobiles merely as a means of transportation."

Many residents were surprised to learn that in 1928, Rockefeller was building a road for motorcars. But while he had resisted the advent of automobiles on the island as long as he could, Rockefeller was pragmatic about the situation once it became clear that they could not be banned completely.

He desired to route the traffic in a way that would preserve the carriage roads he was building within the park. He bowed gracefully to the pressure from the motorcar enthusiasts. "Having built a good many miles of horse roads through our own place and on park and reservation lands there became evident a tendency to feel that motorists were being discriminated against in so far as road construction was concerned," he explained. "Therefore, and because we have always enjoyed cooperating when possible in any movement on the island for the common interest, we offered to build the motor road."

It was a compromise JDR Jr. could live with, knowing that the new motor road would help to preserve his ban on motor vehicles maintained in much of the park. "The preservation of the horse roads from the intrusion of motors has for all time been doubly assured," he said. "The motor road affords as fine, as varied, as extensive and as intimate views of the beauties of the park as do any of the horse roads."

The five-mile motor road began near Kebo Valley in Bar Harbor, ran between Cadillac Mountain and Eagle Lake and ended at the Jordan Pond House. Rockefeller financed the building of the road at the astounding cost

of $80,000 a mile, much of which had to be forged through solid ledge. A few years before, Rockefeller had visited Yellowstone, where he had been disappointed to see masses of stumps and dead trees left along roadsides after construction was finished. No funds had been reserved for cleaning up the debris, so he had donated the necessary money. At Lafayette Park, he was insisting that the project be done right from start to finish. Under Rockefeller's supervision, road builders removed all brush and debris, graded banks and planted them with trees, grass and wildflowers.

The transformation of their home from obscure fishing village to elite summer resort left many Seal Harbor residents shaking their heads in disbelief. In 1926, Charles Clement, one of the oldest residents and one of the most prominent real estate developers, noted that "prior to 1874 Seal Harbor was a little fishing village of six homes for fishing folk and land was one dollar an acre…now Seal Harbor in the good old town of Mount Desert is boasting of the distinction of having the richest men of the whole wide world for permanent summer residents."

Mr. and Mrs. Edsel Ford, June 18, 1924. *Courtesy of Wikimedia Commons.*

John Rockefeller Jr. was well established on Mount Desert Island when fellow second-generation industrialist Edsel Ford bought eighty acres in Seal Harbor near the crest of Ox Hill in 1922 and began building his own cottage.

Ford's situation was similar to Rockefeller's. His family had also attained immense wealth from the latest innovations in transportation technology. While Rockefeller Jr.'s father had been one of the first to make a business out of gasoline (previously considered an oil waste product) to fuel the newly invented automobile, Edsel's father Henry embraced the gasoline engine and created some of the fastest racing automobiles of his time. He

used his success with those inventions to promote his most influential creation: the Model T, a simple, easy to assemble and repair vehicle, affordable for the middle class.

After the ban on automobiles had been lifted on Mount Desert Island in 1913, the Ford One-Ton truck (a modification of the Model T with the same engine) became the vehicle of choice for just about anyone who had to haul anything, from farmers to retailers to builders—in short, just about everyone doing business on the island.

Like JDR Jr., Edsel was an only son, poised to inherit an unfathomably large and profitable business. And like JDR Jr., he showed an unfailing loyalty and respect toward his father. Many felt that Edsel's role was the tougher one, his father being more controlling and more openly critical of his son than Rockefeller Sr. was of his.

When Edsel and his wife, Eleanor, purchased their Seal Harbor property they had two young sons: Henry, age five, and Benson, three. Ford Motor had just purchased the Lincoln Motor Company, and Edsel was busy redesigning the Lincoln luxury automobile.

Ford commissioned fellow summer resident Duncan Candler to design his new vacation home. Soon the rustic, imposing thirty-five-thousand-square-foot building of local granite began to rise out of the forest. Like Rockefeller, the Fords hired Byron Candage, now seventy-five years old, for the masonry work, and although he had lost his son Arthur, he had the help the of his elder son, Samuel. Ford's cottage, to be called Skylands, took over three years to build, and in the meantime the Fords' young family grew to include Josephine, born in 1923, and then William, born in March 1925. Edsel and Eleanor were sometimes visited by Edsel's parents. The senior Fords arrived on Mount Desert Island one summer aboard the steamer *Rangeley*.

During the trip, *Rangeley* captain Joseph Norton of Bar Harbor found the Fords sitting in his steamer's saloon. "I introduced myself," Captain Norton recalled later, "and asked where they were going."

"Seal Harbor," Mr. Ford replied.

"Won't you take a trip through the boat?" he asked the Fords.

But the energetic industrialist needed no invitation to explore anything mechanical. "Oh, we've done that already. We've been in the boiler room and all around," answered the lifelong tinkerer.

Far from being aloof, as Norton had expected, the Fords were eager to get acquainted. "Well, Mr. and Mrs. Ford came with me to the pilot house," Norton recalled, "and stayed there all the way to Seal Harbor. It was the first time we had carried them, for usually they come in their own yacht." Ford

had grown up on a Michigan farm and always retained a down-to-earth point of view, which probably made it easy for him to open up to Norton. "Mr. Ford talked of many things," said Norton. "He is far from being the silent man the newspapers sometimes picture."

A few days later, son Edsel and his family took the steamship to Seal Harbor. When Henry met them at the dock, he made a point to show that he remembered Norton, shaking hands with him and saying, "Sorry I'm not to sail with you again Captain, but the wife and I are to motor home. I know you'll take good care of my son's wife and kiddies."

Henry Ford's labor practices would later come into question, as the employer of thousands of autoworkers fought hard to keep unions out of his business. However, in the 1920s, Norton labeled the elder Ford "one of the most genial, most compatible, most democratic men I have ever known."

"You can tell when a great man is really democratic or just plays the part for effect," said Norton.

Sales of the Model T were beginning to decline, and work was in progress on a new model, the Model A, with Edsel applying his fine artistic eye to the body of the automobile while his father worked on innovations in the engine. Meanwhile Skylands, the granite mansion that seemed to sprout organically from the side of Ox Hill, was ready for occupancy in the summer of 1925. The Fords moved in during a good summer on the island. Momentum had built each year since the Great War, until finally that summer, Seal Harbor saw full occupancy of its cottages for the first time since 1913.

The Fords hired Charles Clement's son, Irving, as superintendent of their estate. In 1925, on one of Charles and his wife's many cross-country motor trips, they stopped in Detroit and met up with Edsel and Eleanor Ford. After a brief visit, Edsel left the Clements in the hands of his private driver, Mr. Tannerhill. "On Mr. Ford's order, I am your man for the day," he told them, "myself and that car we had at Seal Harbor last summer are ready to go wherever you wish." The Seal Harbor couple visited the Ford Motor Works, where a special guide showed them the auto assembly system. They also met some staff who were supervising the construction of Skylands. "The office force gave a fine report of our Seal Harbor boys," Clements said, "and seemed pleased at the way the job is being handled." Under Tannerhill's supervision, the Clements also visited the Ford hospital, the Lincoln car factory and Henry Ford's museum.

The Fords put great emphasis on the landscaping at Skylands and work continued on the grounds after the house was completed. They hired landscape architect Jens Jensen to create for them the sort of understated

elegance for which he was famous. Jensen designed the grounds, but his assistant, Edward Eichstaedt, was more visible on the island, supervising the project on a day-to-day basis. During three years of managing the landscaping, Eichstaedt became a part of the community. He gave talks at local civic clubs and became a popular dinner guest at the homes of Mount Desert Island's year-round business community. He was often on the island, even in the coldest months. In January 1926, even with a deep blanket of snow on the ground, he continued to supervise the removal of boulders and trees so that in the spring, the grounds would be ready for new flower gardens, "which will be full of Maine blooms," he promised. Locals were delighted to discover this included three hundred showy lady slippers, which was nearly extinct on the island.

Thanks to his work with Eichstaedt on the Ford grounds, contractor and excavator Fred Small got to see a little more of the world. Small's work moving trees at Seal Harbor had been so successful that in 1927, when Eichstaedt had a tough project to complete at the Ford family's Grosse Pointe Farms in Michigan, he arranged for Small to travel halfway across the country to be in charge of tree moving and planting.

Duncan Candler went from designing Skylands to designing a new clubhouse at Bracy Cove. With backing from both the Fords and the Rockefellers, the new Seal Harbor Yacht Club included a lobby, lounge, bathhouse, heated swimming pool and tennis courts. One thing Rockefeller and Ford had in common was that they both had grown up in strict Protestant households where drinking was prohibited. JDR Jr. followed his family's tradition, strictly abstaining from alcohol his entire life. Edsel was seen with a cocktail in his hand occasionally (much to his father's disdain); however, he was by no means a drinking man. At their new yacht club, Ford joined Rockefeller in insisting that no alcohol be served. While Prohibition laws might have been broken at Bar Harbor's Swim Club or Reading Room, and a party was apt to result in late-night hilarity and even drunkenness around the island, in Seal Harbor the reserved Rockefellers and Fords presided over a quieter sort of social world where homes and even the yacht club went dark well before midnight.

"Edsel Ford identified himself with Seal Harbor four years ago and the business of converting Ox Hill into a private park and beautiful summer residence is something marvelous," Clement observed a year later. "For three years a small army of men have been at work there and in summer it is a veritable paradise and one of the best things about the whole scheme is the fact that local men have the preference in getting the labor."

The patronage of the Rockefellers and the Fords in Seal Harbor helped to revive Mount Desert Island's cottage real estate economy after the Great War, and for this, the locals heaved a sigh of relief. Work could be had all over the island again and not just any work. Locals lent their craftsmanship to great houses and gardens that were works of art.

A Scientific Campaign

The partnership between Michigan's titans of business and a determined scientist named Clarence Little grew from a network of connections that crisscrossed the worlds of Detroit industry and Bar Harbor recreation in the late 1920s.

Being the niece of Joseph Hudson had meant that Eleanor Ford was connected to most of Detroit's most prominent businessmen, both in and outside the auto industry. Her uncle Joseph had been a Detroit department store magnate who never married. Without children of his own, he lavished attention on his nieces and nephews. Hudson's generosity had propelled Eleanor into exclusive social circles and venues like the Annie Ward Foster Dance School, where, in 1910, she first met Edsel.

Their uncle's sponsorship had even more influence on Eleanor's cousins Richard and Louise Webber. Joseph Hudson groomed Richard to be his successor, and after his uncle's death in 1912, Richard became president of Detroit's largest department store.

Meanwhile, his sister, Louise, married Roscoe Jackson, a hardworking civil engineer. Born in Ionia, Michigan, in 1879, Jackson had been in the right place at the right time to realize his life's passion: the automobile. After graduating from the University of Michigan, he eagerly threw himself into Detroit's booming auto industry, putting his engineering skills to work at the Olds Motors Works. Within five years, he had worked his way up to supervisor of the entire assembly plant. In 1908, he married Louise. In 1909, he had his own automobile company thanks to Louise's uncle Joe, who put up the money for the new endeavor. His

support proved to be not only an act of generosity but a shrewd investment as well. Roscoe and his partners, college friends who had also gone into the auto industry, named the company after Hudson and quickly went to work designing the kinds of automobiles they knew the public wanted. Within a few years, they had established themselves as a contender in the motorcar market with the Essex, a low-priced car that earned high marks for performance. Two years later, the Hudson Motor Car Company blew the competition away with their two-door Essex Coach, an innovative closed automobile at a lower price than had ever been offered before. It would take only one rainy day for the average car owner to see the advantages of the closed car over the more prevalent open touring car. And yet, until Jackson's Essex Coach came along, the closed car had been out of the price range of the average worker.

Hudson became one of the top-ten motor companies in the country at a time when the new market was overflowing with startup contenders. With his engineering skills and drive, Jackson had made good on his wife's uncle's support. The Jacksons followed the Fords' lead and purchased a retreat in Seal Harbor where they could relax and enjoy their growing fortune.

The University of Michigan was one of Jackson's charities. He donated money in particular to a laboratory for scientific research overseen by the university's dynamic president Clarence Little, who also had ties to Mount Desert Island.

Little's rise in the world of academia and research had been swift. Receiving a PhD from Harvard in 1914, by the age of twenty-two, he had already made

The old bridge on the road from Northeast Harbor to Seal Harbor. *Courtesy of Jesup Memorial Library, Bar Harbor.*

important discoveries in the field of genetics through his experiments with mice. At the same time, he quickly worked his way up the academic ladder to become president of the University of Maine in 1921. At thirty-three, he was the youngest university president in the country. Always juggling many roles at once, he also helped found the American Birth Control League (now called the Planned Parenthood Federation) with activist Margaret Sanger that same year and served as scientific director for twenty-five years.

Little was a family friend of Lafayette Park superintendent George Dorr who encouraged him to bring University of Maine students to the island in the summer to research the native plants and animals. Little and students began studying on the island in 1924 first staying at Dorr's Oldfarm. Later, they moved into their own building on the Dorr property that provided not only living quarters but also a rudimentary laboratory to aid them in their research. After a couple of summers Little moved on to become president at the University of Michigan, but even taking that high post did not keep him from pursuing his scientific research. With financial help from Detroit businessmen including many of his fellow Bar Harbor summer residents, he established a new laboratory at Michigan while maintaining his summer laboratory and work with Maine students in Bar Harbor.

Little's fascination with the relatively new field of genetics led him to the eugenics movement that encouraged reproduction among healthy people while discouraging reproduction among the sick or weak. Little shared a notion popular in the 1920s that many of society's problems could be solved

Viaduct over Otter Creek, circa 1930. *Courtesy of Boston Public Library.*

through proper breeding. He found "beauty and idealism" to be "inherent" in this notion, and at the Race Betterment Conference of 1928, he called for "something more than the mere breeding of healthier and handsomer human animals." Eugenics, he claimed, could even enhance "the broader and much more difficult psychological and spiritual values." Not surprisingly, Eugenics Society members were nearly all like Little: white, Anglo Saxon, Protestant and upper class.

In 1929, Little resigned from the presidency of the University of Michigan and obtained a divorce from Katharine Andrew, his wife of eighteen years and the mother of his three children. Back in Bar Harbor in July with two of those children, Louise and Edward, he was staying at a cottage on the Dorr property. With his presidential responsibilities behind him, Little was ready to devote himself full time to scientific research and causes. He became director of the American Society of the Control of Cancer, the organization that was to become the American Cancer Society, and he became president of the American Eugenics Society. Meanwhile, he worked to turn Bar Harbor's Station for Biological Research into a private facility for cancer research. Since he had been a graduate student, Little had been using mice to study ways that cancer could metastasize through heredity. Now he wanted to assemble a group of top-notch researchers to make an exhaustive study of cancer by watching it as it developed in several different families of mice. With its cool summer temperatures, Bar Harbor seemed the ideal place for housing the mice since they bred better in cooler weather.

Sand Beach, Bar Harbor. *Pen and ink by Sara Tarbox.*

The main backer for his project was Roscoe Jackson, whose Hudson Motor Company was thriving with its best sales ever in 1929. But then, suddenly in March 1929, Jackson died of influenza while on vacation in France. He fell sick one day and passed away the next at the age of fifty.

In May, his widow, Louise, had pledged to continue Jackson's support of Little's laboratory with her brother, Richard Webber; cousin Eleanor; and Eleanor's husband, Edsel Ford, all supporting Louise with additional funds. The new facility would be named the Roscoe B. Jackson Experimental Laboratory, and construction was underway on the site of the former University of Maine facility. The new facility, however, would be more than a summer camp. Architect J. Lovell Little, Clarence's brother, designed a brick building with a full basement and three floors housing thousands of mice, along with labs, offices and a library. Local contractor Clarence Dow managed the road construction while Reginald Ingalls served as foreman of the building crew. The brick came from fifty miles west in Orland.

The laboratory was the first ever devoted entirely to scientific study with mice. The building was designed with mice-proof partitions that would prevent the creatures from gnawing through walls if they ever escaped from their pens. It was practically fireproof as well, the architect claimed, due to the brick exterior walls and slate roof.

News of the new laboratory was of interest all over the country. Syndicated press reports announced that "heredity and the laws of growth will be studied in an effort to learn the causes of cancer." And, "If the law of cancer transmission is definitely proved it is held by high scientific authorities that it should be possible through marriage control to stamp out the disease."

Whether or not preventing cancer through "marriage control" was Little's idea or that of the reporter is not known, but Little himself was clearly dedicated to the fight against what was called "the greatest unsolved cause of suffering and death among mankind." Little described two causes. Couched in language for a general audience he said that one cause of uncontrolled or abnormal growth was an "irritation," the other "a hereditary predisposition." In the summer of 1929, Little was ready to settle into his new Bar Harbor laboratory and painstakingly search for a cure. "The problem reduces itself to a slow and laborious investigation," he said. "No individual on the staff expects startling or sensational results and all realize the fact that they are engaging in a scientific campaign and not a single battle."

9
THE HORSE WAS KING

Around the turn of the century, many summer residents hauled their own horses by rail to Maine and ferried them to Mount Desert Island for the summer. Locals knew the season had arrived when they would begin to see manservants in livery driving elegant Victoria carriages drawn by Kentucky Thoroughbreds along island roads, their masters demurely enjoying the scenery from their plush burgundy upholstered seats. The Bar Harbor Horse Show had originally been the creation of the town's board of trade, a group of local businessmen who knew that such an event would be a great way to promote the island. "What is needed at a place like this is plenty of life," remarked one of the board members in 1900, "something to attract people here, to bring them here summer after summer and to keep them here during the season." To that end, the horse show was created, and the rusticators responded enthusiastically. Summer resident and horse lover Philip Livingston stepped in as president and used his blue blood connections to ensure that high society would patronize the event. The Bar Harbor Horse Show became one of the premier equine events on the East Coast at the turn of the century.

While the show had started out as a friendly competition between summer residents, it quickly grew to attract outside exhibitors. Entire stables of show horses were brought to Bar Harbor for the August event, which was held at Robinhood Park on the grounds of the Morrell Estate. Many of the winners in Bar Harbor went on to the National Horse Show in Madison Square Garden.

Bar Harbor Park, now known as Agamont Park, circa 1910. *Courtesy of Jesup Memorial Library, Bar Harbor.*

That was before Henry Ford's Model T and John Rockefeller's gasoline to fuel it completely transformed American transportation. Yet many of the summer colonists resisted the idea of automobiles on Mount Desert Island. They liked the peaceful atmosphere the way it was. While the rest of the world motorized, they wanted their island to remain a memory of a slower, more gracious age, and for a while, they managed to keep the newfangled automobile banned from Mount Desert. A whole different group of people, those whose livings were based on entertaining summer guests and providing them with food and drink, furniture, clothing and keepsakes, could appreciate the innovation of transporting goods by truck rather than boat. In addition to the business people, the doctors were some of the most vocal proponents of the automobile, pleading a life and death need for faster transportation. In fact, the last straw in the argument for automobiles on the island came when one of the local doctors lost a patient due to his inability to get to him quickly.

In 1913, Bar Harbor and most of Mount Desert Island was opened to automobiles, and that spring, preparation was made for the influx of motorists. Ocean Drive got remodeled; the main road to town, Corniche Drive, was widened, graded and straightened and a heavy concrete railing erected on the shore side. "Motor cars here have practically retired the horse," wrote

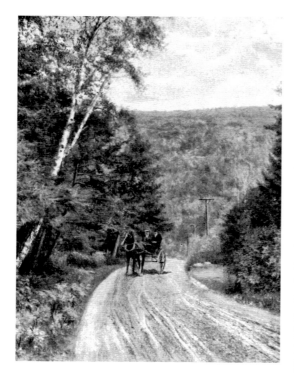

The Gorge Road in Bar Harbor. *Courtesy of Jesup Memorial Library, Bar Harbor.*

a *New York Times* reporter in 1913. "Automobiles of all kinds of descriptions throng the roads of Bar Harbor and have opened up the surrounding country." That very year, Philip Livingston resigned from his position as president of the horse show and the tradition abruptly came to an end.

However, by the mid-1920s, many were ready to embrace the show as nostalgia, a quaint nod to the island's past and a logical counterpart to the carriage road system being developed by John Rockefeller. "The race of horsemen and horsewomen and the legion of lovers of horses are far from extinct," observed local horse lover Albion Sherman. "It would be as sensible to say that steam and gasoline had driven sailing yachts from the sea as to say that the automobile had driven the horse from the face of the earth."

In 1924, the George Kirk Post of the American Legion hosted what it called a Gymkhana, the name deriving from similar British competitions in India. Although the event was hampered by afternoon rain, it was well attended and the tradition successfully revived. Events and participants were by no means on the national scale of the old-time horse shows, but community members, summer colonists and casual visitors alike enjoyed events such as the chariot races and masquerade parade for children on horseback. First prize for this event went to nine-year-old David Rockefeller, who wore an Indian costume "perfect in every detail," on his pony Sunset.

Many spectators also took note of twelve-year-old Joy Louise Leeds's win when she took the blue ribbon with her handsome white pony Sparkle. Once, Joy had been known as the luckiest little girl in the world. Born in obscurity

and abandoned as a baby, she had been sent to a children's hospital where socialite Louise Leeds had first been drawn to the dark-haired infant since she and her husband, Warner, could not have their own. They adopted Joy in 1913, and two years later, they adopted David, then a two-year-old. The New York press made much of the circumstances, marveling at the random strike of fortune that transformed the babies from abandoned orphans to the pampered daughter and son of wealthy parents. "The children have everything in the world that children could possibly want or need," gushed the *New York Herald*. However, David died in childhood, and then a few years later, in February 1923, Joy's mother suffered from a nervous breakdown and went to a sanitarium. Shortly after she returned to her home on East Fifty-Sixth Street, she either fell or jumped to her death from a fourth-story window. The press made much of the $250,000 Joy Louise was to inherit and seemed indifferent to the loss the poor eleven-year-old must have been feeling. In 1924, Joy was in the horse show, with her father looking on as she bravely persevered through her second summer without her mother.

Because 1924's Gymkhana hosted by the American Legion had been popular with the summer colonists, the following year, the Legionnaires were happy to hand over the reins to some of the old guard who had been involved with the event in its prime. Organizers built a new grandstand with five hundred seats plus fifty boxes for wealthier patrons. Philip Livingston resumed his post as president and set out to make the event bigger and the horses more grand than the year before.

In 1926, the show expanded to two days instead of one, and all seats and boxes were sold out. "Thursday and Friday were gala days at this resort with the Horse Show at Morrell Park," reported the *New York Times*. "This affair was witnessed by the largest number of socially prominent people attending any sports event this season and not only was society there, but the financial, scholastic and political worlds were also well represented."

The horse show was back in a big way, with more grass-roots support than it had ever had in former times. "In its best days," observed Sherman, "before 1913 when the horse was king on Mount Desert Island the old horse show had no such generous and widespread support as that given the show last year and this."

Despite their connection to the automobile, the Ford family were among the most enthusiastic participants in Mount Desert Island's paean to the days of horse and carriage and were at every year's show. They would arrive from Seal Harbor with their grooms and a half dozen horses and ponies that were always among the most outstanding. Young Henry handled his ponies with

confidence and often won the children's horsemanship class. His pony Laddie Boy, a handsome bay with the best of gates and manners, often won the title of champion saddle pony. Benson, two years younger than Henry, road with skill as well. One year, Henry and Benson delighted the crowd by pretending to be farmhands, showing a perfectly matched pair of black Shetland ponies before a miniature hayrack while dressed in farmer boy costumes. Edsel Ford's Beautiful Mist, a handsome black mare, was one of the stars of the jumping classes. Eleanor's Irish hunter, Baliengary, wowed the crowd in the open jumping category, a groom doing the jumping while Eleanor watched from her box seat. However, the show was open to female competitors as well as male. Lydia Archibold, granddaughter of the Rockefeller's Standard Oil president John Archibold, won several blue ribbons in 1926 and earned the coveted award of "Best Lady Rider." Lily Tunis of Philadelphia and Northeast Harbor did the ladies one better in 1928 by becoming the racing star of the show, beating all the men as well as the rest of the women. A group of girls from Camp Paysock in Brooks rode seventy-four miles from their horse camp on the mainland to participate every year, a trip that took them three days each way. In their blue knickers and red jackets, ties and caps, they stole the crowd's heart with their choreographed exhibitions. Also from Camp Paysock came Altrose, the Famous High School Horse who entertained with his kneeling, stepping and marching tricks.

Through the '20s, the horse show gained momentum with more and more participation and better-quality horses, particularly in the saddle classes. While some of the fun family-oriented events like the masquerade show and football on horseback competition disappeared, the event regained much of the prestige it had held in Mount Desert's pre-automobile years. Livingston received praise for his renewed leadership, but he also had help from some of the newer summer residents on the island, including Edward Stotesbury, who had not been around in the early 1900s when Livingston had once before built the horse show into a major event. Now Stotesbury was one of the judges and also served as vice-president of the association. While some tension arose between the old guard and the new, the two managed to work together to improve the show every year.

Participants were primarily summer people. Local year-round residents could not afford the kinds of horses that could compete against the stables of the richest families in the country. However, the locals bought tickets in the bleacher seats and turned out to admire the horses, the ponies, the fine riding equipment and the riders themselves, while also getting a good look at the box seats, where the wealthy spectators could provide all kinds of

The Belmont Hotel, near the corner of Mount Desert and Kebo Streets, 1910. Built in 1879, it burned in the fire of 1947. *Courtesy of Jesup Memorial Library, Bar Harbor.*

material for gossip. Local businessmen, who continued to appreciate the way the horse show drew crowds to Bar Harbor and kept the town in the news, were happy to serve in supporting roles as timers, starter, ring master and clerk, of course.

Outside Morrell Park, motorcars sped along island roads, but once every summer, within the confines of the show grounds, the horse was still king. Everyone of a certain age, summer resident and local alike, felt a pang of sentimentality when the Livingstons dusted off some of their grand old finery like the ornate four-in-hand carriage, harkening back to the days when Bar Harbor's elite would clip-clop through town in their gilded tallyhos pulled by gleaming horses. With his sons, Phillip Jr. and Benedict, Livingston also showed three of his best tandems, which gained appreciative applause as the Phillips men followed one another across the exhibit grounds in their gleaming two-wheeled carriages. Livingston delighted in entertaining the crowd with his old-fashioned vehicles that, though now relegated to the category of antique, had once been on the cutting edge of equestrian finery.

10

THE EXODUS

Gotts Island's moorings at Outer Pool went dry at low tide, so leaving was tricky at certain times of day. The larger boats needed to beware of the reef at low tide; the smaller vessels, the rip current. The three-mile crossing could be choppy any time of day. Islanders shrugged their shoulders at these challenges. Four men in a good dory, they said, could get to McKinley even in a nor'easter or a blizzard—that is, if they had to. But they pretty much never had to.

At the turn of the century, the twenty or so families on the island kept chickens for eggs and cows for milk, and the long days of summer yielded enough vegetables to fill their cellars all winter. They had lamb to eat from the flocks they kept on Duck Island, berries to pick, clams to dig and fish, always fish. Getting to the good fishing spots was made easier by their exposed location, and the canneries sent boats out to Gotts regularly to pick up the catch.

Clarence Harding grew up on the island and, in his youngest years, fished with his father in the family schooner. They would stay out for days at a time, catching cod with hand lines. Clarence's elder brother, Charlie, grew up learning to sail, but Clarence never did. The family got a powerboat in the early 1900s, and suddenly, learning to sail didn't seem necessary anymore. The new motor made getting to the good fishing grounds easier, with no need to be out for more than a day. Regular trips to MDI were easier, too, and necessary now that the fishermen had to fill their engines with gasoline. Since they were at Bass Harbor regularly anyway, they started taking their catches directly to the buyers.

The view from Rodicks Island, circa 1915. *Courtesy of Jesup Memorial LIbrary, Bar Harbor.*

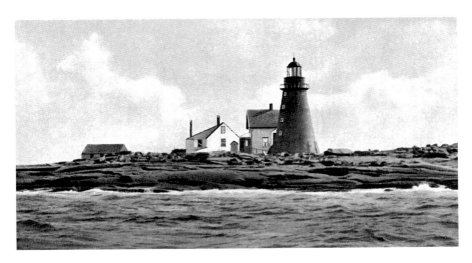

Mount Desert Rock Light, circa 1930. *Courtesy of Jesup Memorial Library, Bar Harbor.*

After high school, Clarence tried business college in Portland, but city life didn't feel right to him. It wasn't long before he was back on the island, trawling for mackerel and trying his hand at lobstering to meet the growing demand for the shellfish. In 1918, he married the island schoolteacher, Miss Hazel Malanson, and two years later, Hazel gave birth to twin boys. Clarence continued to support the family by fishing, often dragging for flounder with Harvey Moore. They fished herring, too, but by the mid-1920s, the herring were getting scarce.

The Moore family ran the store and post office. In addition, Harvey worked on the weir, the fish trap the island men erected annually, and his sailing skills were good for someone his age. In the summer, he could get work teaching sailing in Southwest Harbor.

Will Gott was on the island in the 1920s, too. He had been born there in 1874, a descendant of the original settler Daniel Gott, who raised twelve hardy, healthy children there with his wife, Hannah, in the late 1700s. Will married Emma Joyce, and together they had six children. Their son Charlie married in 1919 and had four children. Charlie Gott stayed on the island and lobstered with his father.

With no motor vehicles on Gotts, a horse could come in handy. In the 1920s, Isaiah Sprague's horse Jack was an important member of the community. Isaiah and Jack would be called on to hay a field, to plow a garden and haul logs or boulders for building projects.

Life on the island was still bountiful in the 1920s, but a menacing presence was threatening the lifestyles the islanders had always known. Perhaps they felt it first in the winter of 1925.

"Never in the history of the island has such a tragedy occurred," wrote the unnamed correspondent in the *Bar Harbor Times*. The "Gotts Island" column was usually one of the shorter town news entries, buried on an inside page, consisting of a few notes about which year-round people had gone off the island to visit friends and family in nearby McKinley or Tremont and which of the former residents of Gotts Island had made the crossing back for a Sunday visit. But the February 4, 1925 issue contained a front-page, heartfelt lament that the islanders had lost one of their most beloved residents. Elizabeth Peterson had been from away, a member of the summer colony, a blue blood from Philadelphia. And yet the small, close-knit Gotts Island community was in mourning, as if she had been one of their own.

The fire raged early on a Thursday morning. But Elizabeth's house was a mile from the village, and the wind was blowing in the opposite direction. No one smelled the smoke, and no one discovered the smoldering, blackened remains of her house until that afternoon. When word circulated and villagers rushed to the scene, they looked immediately for marks in the snow. Not seeing any tracks leading from the house, they were "stricken with horror." They knew then that Elizabeth had not managed to escape. When investigators arrived on Friday, they found enough of her remains to confirm that she had died in the fire.

She had built her house twenty-three years before on the most easterly point of Otter Head. In her upstairs window each night, she lit a lamp to

help guide any wayward boats to the harbors of Mount Desert. Her house was a familiar landmark to all seamen who had ever ventured east beyond Great Gott and a welcome one to anyone who found himself on the Atlantic side after dark.

Elizabeth lived alone, but she was not a recluse. In the summer, she often had visitors. And when her big-city guests left in the fall, she continued to socialize. "She was a friend to everybody," said the correspondent. "A lover of children, always looking after their welfare and pleasure; she took particular pains with the teaching of the Episcopal Sunday School which she had maintained for several years."

She was as rugged as the most weathered islanders. From her granite ledge on the most remote part of the island, she would don her oilskin skirt and rubber boots and make the walk regularly, even through deep snow. "She was a great lover of nature, and one would often see her coming and going from her cottage no matter what kind of storms," said the correspondent. "She loved the winters as well as the summers."

When someone on the island was sick, she would take him or her food. Every Christmas, she entertained the community with a party. "She was a true Christian woman," said the correspondent, "always speaking well of everybody and doing little acts of kindness to others."

Elizabeth's house was one of the finest cottages on the island, furnished in expensive mahogany and filled with delicate china and fine silver that spoke of her Philadelphia heritage. She wore her hair in pompadour that harkened back to the Gilded Age. In fact, it was the kind of hairstyle worn by the women in *Peterson's Magazine*, the popular woman's periodical her grandfather had established in the late 1800s. Most islanders were only vaguely aware of Elizabeth's past. They had known her mother in the early 1900s when she had come to the island with Elizabeth, but they had never seen her father and knew little or nothing about him.

Elizabeth herself probably knew little of her father, Lawrence. He had divorced her mother and suffered from mental illness in his later years. His own father had been tremendously successful in the publishing business and had raised his sons in Philadelphia's highest social circles. With his brother, Lawrence had worked in publishing until retiring young at the age of fifty-four. After that, he had begun to lose touch with friends and family. When he died of a heart attack in New York City in 1915 at the age of sixty, he was living alone in a second-rate hotel on Twenty-eighth Street. Despite having inherited an amazingly large fortune of $10 million from his father in 1887, he was found penniless when he died.

Beyond the estrangement from her troubled father, Elizabeth had her own personal challenges to overcome. No one on the island knew the cause of her disfigurement, but her face was scary, her skin stretched too tightly across the bones, giving her a homely appearance that startled strangers when they first met her.

A genetic tendency toward reclusiveness, a disfigurement that made her self-conscious in high society—these circumstances are probably, at least in part, what led Elizabeth to live her life alone on a remote island. And yet her fate was a happier one than her father's because for all her independence, she was a beloved member of a supportive community.

No one ever determined what started the fire that trapped Elizabeth to perish along with her home and possessions. Perhaps she knocked over a lamp while suffering from a stroke or heart attack. That would explain not only the fire but also her inability to escape. Her remains, what remains there were, were found with her chair that had been in the living room. Perhaps she had been sound asleep when an arsonist had lit the match that destroyed her and her world. No one seemed suspicious of arson at the time, but they were left uneasy by Elizabeth's tragic death.

And to worsen the pain, islanders had two funerals to attend on that bitter day in February. Clarence Harding's father had passed away as well. Less than a year later, more hard times hit the Harding family when Clarence's house and barn burned to the ground during a heavy rainstorm. "I smelled smoke and I looked out through the window. The whole end of the barn was on fire," recalled Clarence later. He grabbed his twin boys, "I got one under each arm and ran across the field and dropped them with my brother, Charlie, and Vera. I ran back and tried to save what I could. It wasn't very much because it went very fast," he said.

The fire had started in the haymow. Clarence always suspected arson, and he always thought he knew who had done it. The next day, the suspect was down at the waterfront talking about how easy it was to start a fire: "All you had to do was take a bunch of cotton waste, soak it in gasoline, put a match to it and toss it up in the hay, and away she goes."

The possible arsonist wasn't the only menace to island life. It was never the reason people gave for wanting to move away. Times were changing. On MDI, folks were getting electric lights and telephones. But Gotts was too isolated and too sparsely populated to warrant underwater cables. On MDI, folks had automobiles, too, and even some of the Gotts Island folks bought cars and kept them at McKinley. But before they could get to their vehicle, they had to boat across the bar into Bass Harbor.

The fire was what finally convinced Clarence and Hazel to move off island, and in January 1928, they purchased the old Jackson house in Bernard. It needed a lot of work, but Clarence and Hazel knew it could be a good home for their sons, a good place to settle after the trauma of the fire and the unsettled years since.

Other year-rounders were moving off island that spring, but with the influx of summer people, the disappearance of year-round residents was not so noticeable. Through the months of July and August, visitors from away strolled the shore studying tide pools and hunting for starfish, joined one another for chowder parties and sailed to Duck Island for picnics. But amid all this leisure activity, the local people spoke to one another of buying houses, moving furniture and starting their children in new schools.

Toward the end of August and into September, the summer people packed up their bathing costumes and sun hats and disappeared, their empty cottages shut up against the cold winds. A handful of year-round residents remained as the nights grew longer, but they, too, had their plans to leave. William Gott was building a house in McKinley; Herman Joyce was going to Winterport to join his mother and sister; Jennie Harding would follow her son Clarence and his family to Bernard. For the first time in 143 years, no one would winter on Gott's Island. The end was clear, and the last of the islanders faced the passing with practicality and determination, just as they and their ancestors had always faced life on their granite island in the North Atlantic.

While the islanders were inclined to leave with little fanfare, the end of year-round habitation on Gotts Island made national news. A *New York Times* story used Gotts to look at the bigger picture of how fishing families on islands all along the Maine coast were leaving their homes to be replaced by summer cottagers. "For the past ten or a dozen years," said author Alfred Eldon, "the exodus from island to mainland has never ceased."

In November 1928, when the exodus was all but complete, Albion Sherman wrote an editorial in the *Bar Harbor Times* in which he noted the island's attributes: the wood was still plentiful and the pool still sheltered boats from the open sea; in addition, he said, "There was no social problem to render the place disagreeable: the stock there has maintained its integrity and not degenerated as isolated communities sometimes do." It was the lack of modern conveniences that did in Gotts Island, he said. Sherman could sympathize and was not the least bit romantic about the islanders leaving their old fashioned, elemental lifestyle. "To live in this period and not to enjoy its mechanical advantages," he said, "is something in a nature of tragedy."

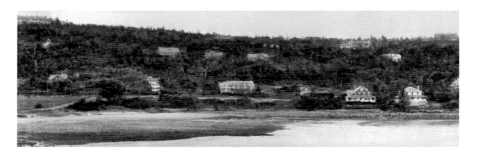

Seal Harbor, circa 1926. *Courtesy of the Mount Desert Island Historical Society.*

"The older inhabitants, born and bred to the isolation of their environment, can stand it," Eldon said. And indeed, they stood it to the last. On a cold day in January, Will and Emma Gott, in their fifties, and widower Isaiah Sprague were the very last citizens to extinguish their kerosene lamps and set out across the bar to McKinley, their backs to their ancestral homes.

THE GAY THRONG

When the Dreamwood Ballroom first opened its doors on a night in June 1927, two thousand people flocked to the new establishment to dance beneath crystal balls to the music of Earl Howard's Colored Serenaders and catch their breath in the late-night air on the broad verandahs. The parking lot overflowed, and cars lined either side of the road all the way over Ireson's Hill and down toward Salisbury Cove. "It seemed as if everyone in Bar Harbor were at Dreamwood last night," remarked Albion Sherman from the *Bar Harbor Times*. "Young and old mingled in the gay throng."

Amid the crowds of thrill seekers in their drop-waist dresses and Oxford bag pants, Daniel Herlihy must have been smiling a satisfied smile. His year of jail time in federal prison behind him, he had refreshed himself with a world cruise with physician-wife Ada. Now he was back in his hometown of Bar Harbor, and if he held a grudge, it was against the feds who had put him away for illegally selling liquor and not with the people of his hometown. Herlihy may or may not have curbed his dealings in the black market, but he was clearly still drawn to the nightlife and still knew how to keep the good people of Mount Desert Island entertained. With money he had stashed away from his bootlegging days, he built a dancing pavilion, a huge wood-paneled ballroom lit by the latest in crystal balls and dome lights, just like the most modern big-city nightclubs.

In the summer of 1927, patrons traveled from as far away as Bangor and beyond to dance the Charleston to bands imported from Boston or New York City. A month after the famous solo flight from New York to Paris,

the Dreamwood's Lindbergh Reception celebrated the famous aviator with flags, balloons and special "Lindy" music. Next was Herlihy's Fourth of July extravaganza, with dancing beginning just past midnight on the third with Ted Wright and Band providing their symphonic syncopations. After dancing the dark early morning hours away, patrons tipped their hat to the Fourth at a sunrise flag-raising ceremony.

Nothing quite matched the wonder and excitement of the ballroom's first year of operation, but while the venue failed to draw crowds in the thousands in subsequent years, it was still immensely popular, especially in the summer. Herlihy planned all kinds of grand theme nights: the Masquerade Ball, the Rose Ball, the Chauffeur's Ball, the Grand Hat Ball with 100 Deauville Beach hats as prizes. To begin the season in 1929, he hosted a Chinese Night with John Fogg and his Doctors of Rhythm, who were garbed as Chinese musicians "so cleverly made up that viewed through the smoke from the incense from the huge gold Buddha at stage center they made a decided Oriental impression," according to one partygoer. The ballroom was a bit of a drive outside the village, but Bar Harborites and summer visitors could board a bus at either 8:30 or 9:30 p.m. on the Village Green for a thirty-cent round trip to the Dreamwood and dance to the live bands well into the morning.

Herlihy even managed to combine trade shows with dancing. His auto show included forty new vehicles on display courtesy of the Bar Harbor Motor Company. The auto show was open from early afternoon until almost midnight on Monday, Tuesday and Wednesday, and along with looking at the latest Packards, Nash and Dodge Brothers automobiles, attendees kept on dancing.

As the 1920s progressed, the party was getting louder for Bar Harbor's wealthy summer visitors as well. The old guard's rusticators were giving way to newcomers with less interest in the resort area's quiet atmosphere of popovers, tea and late-afternoon strolls. A lively, modern attitude was beginning to make its mark on Bar Harbor's elite social scene. "Of late the tempo has changed a little with the arrival of new money from Chicago, Cincinnati and other cities once socially out of the spotlight," commented R.L. Duffus in an article about Bar Harbor in the *New York Times*. Three new families stood out for spending the most money the most lavishly: the Kents, the Stotesburys and the Palmers.

"Come in and look over our attractive line of Atwater Kent radio sets," Main Street retailers Abbott Electric Company suggested in a local 1926 ad. While Bar Harborites and the rest of the country were snapping up Kent's product for "the utmost satisfaction in radio performance," he was often

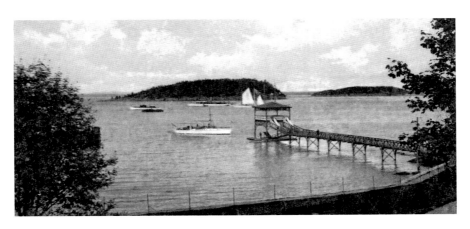

Eastern Yacht Club Pier, Bar Harbor. *Courtesy of Jesup Memorial Library, Bar Harbor.*

on Frenchman's Bay lavishly spending the profits. Born to a New England doctor, Kent took an interest in mechanical engineering at a young age. While still in his twenties, he invented the unisparker ignition system that became the automobile industry standard for almost fifty years. When he was in his forties, his main interest changed to radios, and by 1924, he had established a manufacturing plant in Philadelphia. Success came quickly. By the following year, Kent was the biggest manufacturer of radios in the country at a time when every family wanted to stretch their budget to own one. By 1929, Kent's twelve thousand employees were busy manufacturing one million radio sets in Philadelphia while Kent spent the profits on prime waterfront property, fleets of speedboats and lavish all-night parties in Bar Harbor. In 1927, at the age of fifty-four, he purchased Sonogee on Schooner Head Road, an Italianate villa with a low-pitched red tile roof and cream-colored stucco, formerly owned by Frederick Vanderbilt. Like most of the new owners in the late '20s, one of Kent's first remodeling projects was to turn the carriage house into a garage. He made it big enough for a dozen motorcars, adding a car wash and sixteen small bedrooms above for staff. The following year, he bought Brookend, the estate on the other side of Duck Brook, because two mansions on Schooner Head Road were always better than one. Kent could afford the indulgence. His ignition systems were still the industry standard in the auto world, and meanwhile, his own company was the biggest manufacturer of radios in the country. Profits were pouring in faster every day.

Once settled, he and his wife, Mabel, began to entertain, and when the Kents threw a party, everyone in town could hear the echoes of music across the water as the orchestra played from a yacht anchored off shore.

In 1925, Ned and Eva Stotesbury made a splash in Bar Harbor when they bought Wingwood House on Eden Street north of the village and quickly proceeded to spend $1.3 million bringing the cottage up to the most modern standards of comfort and convenience, with fifty-six electric wall heaters, five hot-air furnaces, twenty-eight bathrooms and fifty-two telephones. While the old guard tolerated drafty rooms and shared bathrooms in their rustic summer cottages and felt no need for a telephone at every turn, the Stotesburys had no desire to be rusticators. They wanted warmth at the turn of a knob and constant communication on the best of telephone systems. In a nod to their notion of Old World charm, they imported twenty-six hand-carved marble fireplaces from Europe; to accommodate all the guests they intended to host for their parties, they expanded to eighty rooms, and because no one can keep up an eighty room cottage alone, they included a thirty-room servants' wing.

Like Kent, Stotesbury was a self-made man; he had risen from grocery clerk to prominent Philadelphia investment banker. The Stotesburys' reputation preceded them to Bar Harbor but not in a good way. Stotesbury was estimated to be worth upward of $100 million (a billionaire by today's standards), and the family made national news for their scandals as well as their wealth. In 1923, Ned's son-in-law John Mitchell had been implicated in the murder of cabaret dancer Dorothy Keenan, described by the *New York Times* as a "flashily-dressed, gem-fond Broadway habitue." Mitchell had admitted to having an affair with Keenan, and it was discovered that love letters he had written to her had been stolen from her apartment at the time of the murder. Mitchell had an alibi for his whereabouts the night of the murder and was never charged with the crime, but the details of his affair made for popular reading at the time, and the stench of scandal was on the family.

Their reputation wasn't helped any the next year when Senator Burton Wheeler implicated Stotesbury in a political fundraising scandal. Stotesbury was a director of the United Gas Improvement Company, which controlled most of the lighting companies throughout the United States. In the early '20s, a complaint was filed charging United Gas with violating the antitrust act. In 1922, the matter was submitted to a grand jury in New York and an indictment returned. Some of the directors were indicted for their crime but not Stotesbury. Wheeler claimed Stotesbury got off the hook only because of his friendship with Attorney General Daugherty and his generous contributions to President Warren Harding's campaign.

After Stotesbury became their neighbor, Bar Harborites were still reading about his exploits in the news. In 1928, he was badly injured in an auto

accident in Philadelphia when his limo hit a car driven by "a negro" named James Sanders. Readers probably raised their eyebrows when noting that the accident happened when Stotesbury was returning from the opera with another woman while his sick wife stayed at home. News items also failed to explain why African American Sanders was arrested on a charge of assault and battery when Stotesbury's limousine had hit *his* car.

No doubt *New York Times* correspondent R.L. Duffus was thinking about Potter Palmer in 1929 when he referred to "the latest Chicago millionaire," in Bar Harbor, "full of energy and dripping dollars from every pore." Chicago's first Potter Palmer had grown up on a farm in Upstate New York and rose to become a successful retailer in Chicago and then an even more successful real estate developer. The family had been a part of the Bar Harbor social scene since the leisurely paced Gilded Age, often staying at Mercer Cottage on Clefstone Road. After his parents had both passed away, Potter II and his wife, Pauline, continued to vacation in Bar Harbor with their four children. In 1925, they rented the Fabbri estate, Buono Riposo on Eden Street, and liked it so much they wanted to buy, but Mrs. Fabbri turned down their offer. "I for one, am glad she did," wrote Pauline Palmer to her mother soon thereafter. "We are going to rent something else and let others do the worrying." The four children, ranging in age from ten to sixteen, loved Bar Harbor in summer. "They have had the best time and are happy as the day is long," reported their mother, who nevertheless despaired over sixteen-year-old Palmer's late nights with "a very second-rate crowd." Of her own social set, she said, "I think we are making a nice group, quite a varied one, but awfully nice." All in all, she deemed their stay in Bar Harbor "a howling success!" In 1926, the Potters were back at the Fabbri estate, but Pauline's desire to rent rather than to take on the responsibility of cottage ownership had changed by August. The family invested in Bar Harbor in a big way with the purchase of a vast tract of land along Schooner Head Road, taking in not only eighteen acres of the former Kettle property but also the fifty-four-acre Hare Forest estate, making their new investment one of the largest pieces of oceanfront property in the area.

Hare Forest had always been a lovely cottage, but like many of the big summer homes along the water, it had been a rustic one. Now the Palmers wished to renovate in grand style, to compete with the Stotesburys and the Kents in making their cottage the most impressive. The house on a cliff commanded a broad view of Frenchman's Bay and Ironbound Island from the upper stories. Bar Harbor's A.E. Lawrence Company went to work building a new wing onto the mansion and a large new terrace for

entertaining. Pauline added modern flair by doing away with the ornate wallpaper and painting the walls in neutral colors of ivory, buff or white while wall hangings, rugs and furniture lent vivid color. The Palmers would not stand for the old rudimentary plumbing that had been used by the rusticators of the past. A new system was installed throughout. No longer would the cottage feel drafty during a September rain; no longer would the late-season guests feel the need to huddle all day around a fireplace. Local heating experts Green and Cop installed two new hot-air heating plants to serve the main house and the new wing, and heat plugs were installed in every room. The house was completely rewired; a state-of-the-art intercommunicating telephone system for summoning the help was added, as was the newest in lighting fixtures.

Of course, the Palmers kept motorcars on the island rather than horses, and their friends and visitors needed places to park their motorcars, and their children's friends all had motorcars. So, a new two-car garage was added at the service end of the house with quarters on the second floor for manservants. And another three-car garage was added near the caretaker's lodge.

Once settled into Hare Forest, the Palmers joined the Kents and Stotesburys in Bar Harbor's ongoing round of summer social events. They patronized the horse show, contributed to the YWCA, swam, played tennis and partied at the resort town's long-standing Swimming Club. The club had always been an important and traditional piece of Bar Harbor summer life for society's old guard, but to the new patrons, the place seemed outdated. Duffus described it as "a pleasant, unpretentious spot," which was not what this new set had in mind at all. In comparison to their state-of-art cottages, freshly painted and full of the latest innovations in comfort and convenience, the club felt old and shabby and out of date. The set had no time for memories of the Gilded Age. They wanted to be modern.

They wanted their club modernized as well, and they began shaking things up at club meetings. The first big step took place in August 1928, when the club purchased the adjoining lot on West Street. New members envisioned an expansion, or maybe even the demolition of the old building with a new one built in its place. But more funds had to be raised, and many of the new guard felt that some of the long-standing members were in their way. Foremost among the old-timers was club president Philip Livingston, most definitely a man of convention and tradition. The wealthy Livingston family was quick to tell anyone who asked, and even those who didn't, about their illustrious history: their ancestors had founded Livingston Manor in New York after receiving a grant from

Bar Harbor Swimming Club, circa 1935. *Courtesy of Jesup Memorial Library, Bar Harbor.*

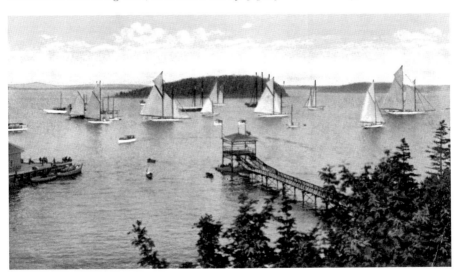

The harbor and yacht club pier, Bar Harbor, circa 1933. *Courtesy of Jesup Memorial Library, Bar Harbor.*

Queen Anne in the early 1700s, and they were directly descended from the Philip Livingston who fought next to George Washington and later signed the Declaration of Independence. The family had been mainstays in Bar Harbor since the Gilded Age, maintaining several estates, including Silver Birches on Eden Street; donating monuments to the town like the Italian

fountain in the village green; and always taking an active part in traditional Swimming Club activities. The current Philip Livingston had graduated from Columbia law school in 1886, had practiced law until he was thirty-nine and had then retired to pursue his interests in boating and horses. He had been key in organizing Bar Harbor's successful horse show and had won the four-in-hand half-mile run at the event for eleven years in a row.

But Livingston's influence was waning in the face of newer money and more energetic Swimming Club members, more and more of whom desired change. In September 1928, Livingston bowed to pressure and sold his shares in the club, over 50 percent of the outstanding stock, to Ned Stotesbury. He also resigned his presidency, and Stotesbury took on the leadership. The club was now in the hands of the modern set, and the party was sure to continue.

A Gracious but Dying Tradition

At the beginning of 1929, President Coolidge signed a bill changing the name of Lafayette National Park to Acadia. Secretary of the Interior Roy West explained that the name change came about because the National Park policy was to "employ names only descriptive of the region or associated with it in popular legend from earliest times." When early explorer Giovanni Verrazano had first recorded the name "Arcadia" on a map designating a huge region that included Canada's Maritime Provinces and the Northeast coast of the United States, the word referred to an idyllic unspoiled wilderness. Variations, including "Acadia," had been used ever since in reference to the Bay of Fundy and Gulf of Maine shorelines.

The Forty Hayseeders set the date for their annual ball for Wednesday, February 6, in 1929 but then came the sudden death of member Joseph Norton, captain of the Maine Central steamer the *Norumbega*. Kind and interested in people, Captain Norton was also respected as a man of the sea. He had begun work as a deckhand on a steamer when he was just twelve years old, had taken command of the *Norumbega* at thirty-three and had served as its captain for twenty-seven years. After his demise from a heart attack at his home on Greeley Avenue, townspeople mourned his death. They didn't feel right about throwing a party so soon after losing such a prominent Hayseeder and member of the community. The ball was postponed until the following Monday out of respect to his memory.

On that night, about five hundred guests in wide-brimmed hats, overalls and long gingham dresses poured into the casino. The decorating committee

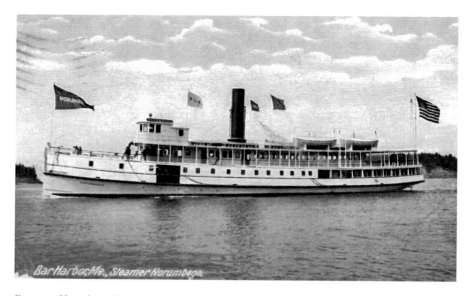

Steamer *Norumbega*, circa 1905. *Courtesy of Jesup Memorial Library, Bar Harbor.*

had outdone themselves: burlap was strung across the balcony, sheaves of hay and straw were strewn around the floor, old lanterns, oxen yokes and strings of cow bells hung from the walls. On the menu was traditional fare: coffee, homemade donuts, wedges of cheese, smoked herring and salt fish. Homegrown talent entertained with dances, songs, vaudeville acts and impersonations. Mrs. Gerald Hodgkins sang "She's the Sunshine of Paradise Alley" and "Daisies Won't Tell." Dr. Frank Carroll sang "My Indiana Home" and "Carry Me Back to Old Virginia." Leaman Smith and William Woodside played harmonica and clattered rhythm bones. There was a "black face" performance and a cringe-worthy description of it in the newspaper. "They were 'coons' of the blackest variety and their talents were as decided as their shades," the correspondent wrote. Hud Kelly called off the square dancing long into the morning hours leaving quite a few sleepy people around town on Tuesday.

In April, Bar Harbor was abuzz about the ten-foot-tall electric clock going up on the front of the First National Bank building on Main Street. In celebration of strong economic times, the bank commissioned a clock made with copper, bronze and brass, finished with statuary bronze, the bank name boldly displayed above the face in art glass letters. The clock was guaranteed to keep perfect time with a complete set of Westminster chimes that would ring every quarter hour. "Years of prosperous banking have been

The clock at First National Bank on Main Street. *Photograph by Luann Yetter.*

made possible only by your support," bank vice-president George Berry announced to customers. "We wanted to show our appreciation in some big substantial way…a large handsome clock combined with a set of the softest and most beautiful chimes ever heard in any city of the old or new world." The new chimes seemed to speak of prosperity and good times to come.

At the beginning of May, the Star Theatre screened *Close Harmony*, a romantic musical that owner Joel Emery proclaimed was "a one hundred percent talking picture."

"I'm thoroughly convinced that this new art is revolutionizing the field of motion picture entertainment," he said, "and, as always, I'm determined that the Star shall have the best, both in equipment and pictures." Emery had been studying moving pictures with sound since they had first come out less than three years before. "During this past winter," he said, "I became satisfied that this new and popular entertainment had taken such strides as to make certain its continued development." He explained that he had chosen this particular movie "for its ability to show the power of sound in presenting dialogue, singing and instrumental music." Townspeople flocked to the theater, and hundreds were turned away from the first show Monday night. By July, movies with sound were going strong at the Star, bolstered by event releases like the Marx brothers' *The Cocoanuts*, advertised as "the screen's first musical comedy, all-talking-singing-dancing."

Meanwhile, live entertainment took center stage at the high school when students presented their "Whoopie Revue" to a crowd that packed the casino. The production included the "Six Blackberry Wisecrackers" with their "line of chatter full of clever jokes" and each of the four classes presenting a "snappy vaudeville sketch."

Also in May, the Dreamwood Ballroom opened its season with the Rose Ball. Opening night brought 1,300 patrons to enjoy a "floral fairyland" of decorations. John Fogg and his Doctors of Rhythm played on stage amid decorations of trees and tall grasses that added to the outdoor effect. With the Dreamwood Ballroom well established, Dan Herlihy had new ideas up his sleeve. Spectator sports were becoming increasingly popular around the country in the late 1920s, and boxing was one of the biggest draws. Jack Dempsey, world heavyweight champion from 1919 to 1926, had helped to swell the sport's popularity to a paying, and mostly male, crowd. Herlihy, ever eager to enlarge his entertainment empire, got into the boxing business in 1929 with his new Dreamwood Stadium, which opened on the Fourth of July with a boxing match that attracted 1,500 fans. In the first heavyweight bout, Johnny Bouchard of Old Town beat Owen Flynn of Boston. "Owen Flynn is a mighty

good boy," reported the *Times* sports correspondent, "and Johnny Bouchard's win over him is a feather in his war bonnet to be proud of."

Jack Burton of Orono opened the show with a knockout win over Young Morse of Bar Harbor in the second round. "The Orono fighter was much too classy for the seacoast boy who tried hard but was caught with left after left to the face which kept him off balance all the time," reported the *Times*. Morse lost in a knockout in the second round.

Talk turned to the summer to come as the town readied itself for the inevitable crowds of visitors. Business had steadily increased with nearly every summer since the war had ended. Now hotel men were reporting advanced bookings again, with some families booking suites for the entire season.

Many of the increasingly numerous National Park visitors stayed in the traditional Bar Harbor hotels and took sightseeing trips to the park, but more and more outdoors types were bringing with them their fly tent and patent stove and enjoyed roughing it in the campsite near Morrell Park, just south of Bar Harbor. There, campers had access to water and a telephone and were allowed to cut their own wood.

Construction on the Cadillac Mountain summit road began in July. A section built in 1927 already reached 700 feet, and the new section would reach the summit, 1,532 feet above sea level, the highest point on the Atlantic coast. One of the pastimes of the summer for locals and visitors alike was to

The entrance to Acadia National Park, circa 1930. *Courtesy of Boston Public Library.*

The view from below Rockefeller Drive, Acadia National Park, circa 1930. *Courtesy of Boston Public Library.*

hike up the mountain to the construction site to marvel at the state-of-the-art steam shovel at work pulling up stumps and moving great piles of dirt.

Duck Brook Bridge, the main Bar Harbor entrance to the magnificent Rockefeller Driving Road system, was completed at a cost of close to $80,000. The Candage brothers, local masons often used by the Rockefeller family, constructed the bridge of granite with concrete reinforcement in a design that effortlessly became a part of the natural landscape. Much of John Rockefeller's carriage road system was complete, providing eighteen miles of main loops and another twenty miles of branch roads, all closed to motor traffic. Anyone who saw the well-constructed and landscaped roadway and massive yet artful granite bridges marveled at their beauty, and the business community marveled at its good luck at having a patron like John Rockefeller willing to invest upward of $1 million in park infrastructure. By the end of the summer, the park would boast visitor numbers well over the previous year at nearly 130,000.

On Mount Desert Island, horses could still be found pulling summer colonists in four-in-hands and Victorias along the winding web of carriage roads where twentieth-century motorcars were prohibited from spoiling the nostalgic charm. "If you wish to find the mellow twilight of nineteenth century summer social life in America lingering on into the glaring forenoon of the twentieth, you can hardly do better than go to Bar Harbor," noted Robert Duffus in the *New York Times* magazine that summer.

Arch Bridge at Bubbles Pond, postmark 1932. *Courtesy Jesup Memorial Library, Bar Harbor.*

Maine Central Steamers, the *Rangeley* and the *Norumbega*, still plied between Mount Desert Ferry and Bar, Seal, Northwest and Southeast Harbors, serving those who traveled by train to Hancock Point on the mainland. But some of the more adventurous and wealthy travelers were now arriving on the island by air. In mid-August 1929, Curtiss Flying Service had established regular and direct weekend flights between Boston and Bar Harbor. The six-passenger plane made the journey in two hours, and company officials were quick to point out that the round-trip cost was only about six dollars more than taking the train. The flights were piloted by Bar Harbor native George Rumill, who had been in the U.S. Naval Air Service during the world war. Those who knew George best say he had sunk a German submarine in the Irish Sea, but he wouldn't say.

Bar Harbor's annual Fourth of July celebration attracted an estimated ten thousand visitors. The town's parade drew the biggest crowds, who cheered as officers and men from the USS *Detroit*, at anchor in the harbor, marched along Main Street, followed by one thousand Boy Scouts who had come from all over the northern part of the state to camp on the island. Three bands kept the marching music flowing as countless floats decorated with colorful crepe paper streamers moved slowly past the crowd. Marshal Albion Sherman led the parade atop a Kentucky Chestnut gelding from the stables of David Jackson of Morrell Park. Miss Frances Brewer won the automobile

division driving her yellow and green Reo roadster. The American Legion Auxiliary won first prize for its decorated car, completely covered in white crepe paper and red poppies.

In the afternoon, the Boy Scouts took part in a field day that included contests in signaling in Morse code, a "carrying of the injured" relay, a standing broad jump relay and an archery contest. The fire by friction contest was dampened by afternoon wind and rain, bringing an early end to the competition.

The birthday of patriarch John Sr. on July 8 marked the annual migration of the Rockefeller family to their sprawling half-timbered cottage overlooking Seal Harbor. Sequestered in the Eyrie, they guarded their privacy as always, but from the highway below, tourists in their motorcars would stop to gaze up at the hundred-room mansion, marveling at the wealth and power it represented. Such power could not cure all ills, however, such as when late in the summer, nineteen-year-old Laurence suffered an appendicitis attack. His return to Princeton for sophomore year was delayed as he underwent an operation at the Bar Harbor hospital.

Tennis Week was a huge success, with three British naval ships in harbor for the event at the first of August. The British officers convincingly defeated the team from the American warships in the Swimming Club tournament. Afterward the club played host to the biggest navy ball yet in honor of visiting British and American officers, who mingled with summer colonists in the ballroom made colorful with reappropriated signal flags from the warships. Outdoors, where single officers strolled with the eligible young ladies of the colony, the grounds were strung with lights and colored lanterns.

"About it there hangs the rose-and-old-lavender fragrance of a gracious but dying tradition," Duffus said about Bar Harbor's old guard in the summer of 1929. Many summer colony traditions established back in the Gilded Age of horse and carriage had continued through the Roaring Twenties in Bar Harbor, where even the younger set looked to relive precious summer memories. Like so many social events on the island, the ball had gained momentum in the years since the end of the world war, and the 1929 affair attracted nearly six hundred summer colonists.

When the Honorable Henry Morgenthau, former U.S. ambassador to Turkey, spoke at the Congregational Church on the Sunday evening of Tennis Week, he declared that that "the United States is now one of the leaders of the world." In an observation that may not have been especially diplomatic while Bar Harbor was in the midst of entertaining the British navy, Morgenthau went on to assert that "Great Britain has handed the flag

of civilization to us." Morgenthau felt secure in the leadership of President Herbert Hoover, "a man who is thoroughly conversant with our domestic as well as our international affairs."

On the heels of Tennis Week came the Bohemian Cabaret, a benefit for the local hospital and one of the largest affairs of the season. The event was planned by the club's younger crowd, who decorated the clubhouse to look like an Art Deco New York City nightclub and enlisted some cabaret entertainment, including Max de Schauensee, son of the Baroness Meyer Schauensee and future music critic for the *Philadelphia Evening Bulletin*, who sang "Softly within a Morning Sunrise" and Sarah and Mary Zantzinger, daughters of Philadelphia architect Clarence Zantzinger, who tap danced to "I Can't Give You Anything but Love."

Duffus described the Swimming Club as "a pleasant, unpretentious spot, with a dance hall, a dining room, tennis courts, and an enclosed swimming pool which is several degrees warmer than the congealing North Atlantic," but the facility was about to go under a major overhaul in the winter of 1929–30. New blood, and new money, was making itself heard as self-made financier Edward Stotesbury replaced blue blood Phillip Livingston as president. Allied with new vice-president Potter Palmer and board member Atwater Kent, Stotesbury was pushing for sweeping renovations. Before the following summer, the new directors would manage to get rid of the unsightly coal-fired garbage incinerator that marred their waterfront view, buy up additional adjoining land and sink $200,000 into their project. They would enlarge the clubhouse to twice its original size and put in a larger swimming pool and additional tennis courts. The results would be not only a new facility but also a new name: the Bar Harbor Club. But in the summer of 1929, the Swimming Club was what it had always been to the old guard, with Max de Schauensee's operatic voice wafting sweetly across the old ballroom.

Joy Louise Leeds was back in Bar Harbor in the summer of 1929 staying with her mother's family, the Hartshornes, at Spruce Lodge. The girl no longer called herself "Joy" but chose to go by her middle name, which had once been her mother's. After her mother's tragic suicide in 1923, Joy Louise watched her father's health decline rapidly. In 1925, when Joy Louise was thirteen, her father passed away. The former "waif" and "hospital castaway" who was adopted from poverty as a baby was once again an orphan—this time, an orphan with an inheritance of nearly $3 million (equivalent to $40 million today).

Bar Harbor's Yacht Club had found a new home in the former Reading Room near the harbor and was more active than it had been any time since

before the Great War. In August, William Cudahy of Northeast Harbor beat out the best crews on the entire north shore to win the Sears Cup for the Bar Harbor Yacht Club at the prestigious Marblehead Championship.

Gossip spread up and down the wharves as boating people speculated about Edsel Ford's new yacht, the *Sialia*, being built in Massachusetts at a cost of $400,000. The auto designer and magnate had commissioned a "sea greyhound" that would fly across the water at a speed in excess of sixteen knots an hour. Ford was sparing no expense to make the yacht the last word in fast cruiser construction. It would house twenty guests or more in cabins, staterooms and salons luxuriously finished in teak, French cedar and butternut. Five staterooms were getting equipped with baths, and there would also be a dancing salon, a dining room, a living room, a captain's stateroom and a pilothouse.

In August, the annual Horse Show took place at Morrell Park, the revived tradition once again the pinnacle of the summer season. The program began at 2:30 p.m. on Monday and Tuesday afternoons with Bar Harbor's business people crowded into the reserved seats and members of high society filling the boxes. The McCormicks, Rockefellers, Fords, Stotesburys, Kents, Palmers, Hartshornes and Jacksons were among those who spent the late afternoon and early evening sipping tea served by local staff, admiring their family's and friend's entries from their box seats. Ned Stotesbury served as one of the competition judges and Judge Charles Pineo as one of the timers. Henry Ford II won the saddle horse class with his handsome chestnut White Sox and placed in many categories. Philip Livingston, driving Princess and Commodore, easily won the harness pairs class with son Philip Jr. in second place, the New York Livingstons beating out the upstart Michigander Henry Ford II, who came in third. But it was Ford's chestnut mares that took the award for saddle horse pairs.

Draft horse classes were a feature of the show for the first time in 1929. J.P. Morgan's son-in-law William Pierson Hamilton beat out all the local working horses with his magnificent Belgians from Thirlstane Farms, winning all the ribbons and taking home the Grand Championship prize for 7,500-pound Queen de Furnes, deemed the most perfect horse in the show.

After the horse show, summer activity began to wind down. Servants at most of the cottages were busy closing shutters, stripping beds and clearing pantries while their bosses boarded steamers to escort their children to private schools in Massachusetts or return to offices on New York's Broadway or Philadelphia's Market Street.

The summer people did not want to leave their island haven any more than the locals wanted to see them and their bulging wallets move on. But for

those remaining, the fast tempo of summer inevitably slowed to the mellow pace of autumn. Locals strolled through the annual Eden Fair admiring the produce displays of tomatoes, squash and pumpkins and inspected the mules, oxen and poultry in the livestock barns. The rich green of summer paled to the burnt colors of autumn, and the spitting snow spoke of the white winter to come.

But rusticator and native alike looked forward to the next high season with unguarded optimism, the first summer of the new decade certain to be the roaring success they had come to expect from the carefree summers of the '20s. After only a few harbor-freezing, snow blanketed months, a fresh wave of free-spending rusticators would again fly into the Curtiss airfield, steam across Frenchman Bay and throw their Hudsons into high gear across the Mount Desert Island Bridge for another whirlwind season in Acadia.

AFTERWORD

On October 28, 1929, the stock market crashed, but the events of Wall Street felt far removed from Mount Desert Island. The next morning, Bar Harbor fishermen took to their lobster boats, merchants opened their stores and students gathered their books for school much like any other day. They didn't know then that within the next two years, the stock market would continue to decline until nearly 90 percent of its value had disappeared and 25 percent of the workforce would be unemployed. The Great Depression lasted ten years. It was followed by World War II, and in Bar Harbor, the Second World War was followed by the most devastating fire in the town's history. It would be a long time before Bar Harborites enjoyed another carefree summer.

In 1932, when rumrunner Dan Herlihy died of pneumonia at the age of sixty-four, he was lauded as a "popular businessman" in the community, and the obituary in the local paper went on to provide evidence: "At the house Monday the beautiful display of flowers was like that of some conservatory…Hundreds of tall, white lilies, masses of roses in every tint, with every hue of the garden represented."

Herlihy's Dreamwood Ballroom remained open through several years of the Depression until Christmas Day 1936, when it was destroyed by fire of an "undetermined origin." When the Dreamwood Ballroom went down in flames, the sounds of the orchestra were silenced forever on Ireson's Hill.

In the early 1950s, the Rockefeller family decided that caring for a vacation home of nearly one hundred rooms was impractical and determined to

Public campgrounds, circa 1930. *Courtesy of Boston Public Library.*

tear down the Eyrie. The house had been redecorated at the hands of Rockefeller's second wife. But before the place was demolished, his children wished to capture it the way they remembered it from their childhoods. The family restored the interior to the way it had looked in the 1920s when their mother, Abby, had decorated with her world-class collection of paintings and oriental objects. The rooms were then photographed to capture the way the six Rockefeller children remembered them.

Edsel Ford died of stomach cancer in 1943 at the age of fifty-three. Skylands, the Ford's Seal Harbor estate, stayed in the family until the 1970s, when it was sold to the Leedes family. Martha Stewart has owned Skylands since 1997.

In 1930, Jackson Lab founder Clarence Little married his lab assistant Beatrice Johnson. Little left the Jackson Lab in 1954. He later became a leading scientific voice of the tobacco industry. In 1959, he stated that smoking does not cause lung cancer and is, at most, a minor contributing factor. A decade later, he was still maintaining that smoking cigarettes did not lead to any disease. He thought the main cause of cancer was genetic, not environmental.

In 1938, investment banker Ned Stotesbury died at the age of eighty-nine, his wealth only a fraction of what it had been when he had made a splash in Bar Harbor with his lavish renovation of Wingwood. His wife, Eva, held on to Wingwood until her death in 1946. By 1952, the once

grand estate had fallen into a deplorable state of disrepair when it was purchased by the Canadian National Railroad for their ferry terminal. "No one is interested in maintaining these old palaces anymore," was the official Canadian National pronouncement before Wingwood went the way of many of Bar Harbor's once loved summer homes: neglected, abandoned and, eventually, demolished.

After enjoying a revival in the 1920s, the horse show abruptly ended after 1929. In the midst of the Depression, few people could afford to transport their horses to the island for the summer.

The municipal casino was torn down in 1970. These days, the Hayseed Ball takes place in a conference room at the Atlantic Oceanside Hotel. Though the venue has changed, upward of three hundred Bar Harborites still gather on a winter night for old-time music and dancing, just as their predecessors did in the 1920s. The event is still planned by a group who proudly refer to themselves as the Forty Hayseeders.

BIBLIOGRAPHY

Baltzell, Edward Digby. *Philadelphia Gentlemen: The Making of a National Upperclass*. New York: The Free Press, 1958.

Bar Harbor Record. "The Opening. Bar Harbor Casino Christened by a Big and Happy Crowd." July 31, 1901.

Bar Harbor Times. "Bar Harbor Girl Weds Naval Reserve." December 14, 1918.

————. "Bar Harbor Newspapers Tell the Story of 75 Years of Island History." August 30, 1956.

————. "Believe All Snow Records Broken." January 17, 1923.

————. "Buys Kettle Place and Hare Forest." August 18, 1926.

————. "Capt. George E. Kirk Dies in France." December 21, 1918.

————. Chautauqua advertisement. July 16, 1919.

————. "Deputy Clark Gets 600 Gallons Rum at Manset." March 28, 1923.

————. "Describes Winter Life at Mount Desert Light." March 28, 1923.

————. "Dr. Little Explains Laboratory Work." December 4, 1929.

————. Editorial. November 21, 1928.

————. "Edward B. Kirk Died Friday A.M." September 5, 1928.

————. "Fred Small to Move Trees in Michigan." January 26, 1927.

————. "Girls Ride 74 Miles to Show." August 22, 1928.

————. "Hare Forest Most Attractive Estate." May 18, 1927.

————. "Horse Show Held on Monday and Tuesday." August 21, 1929.

————. "Juliette Nickerson 80 Years Old Wednesday." April 18, 1923.

————. "Marines Leave Bar Harbor Tuesday." March 15, 1919.

————. "Meets Death in Burning Cottage." February 4, 1925.

————. "Miss Porter Wins Croix de Guerre." June 25, 1919.

————. "Mr. and Mrs. Leeds Adopt Boy." November 20, 1915.

————. "Mr. Rockefeller Discusses Park Automobile Road." August 8, 1928.

————. "Mrs. Kendall Bride of Captain Roberts." January 14, 1920.

————. "Mrs. Warner Leeds Plunges to Death." February 14, 1923.

————. "New Edsel Ford Boat Launched." November 20, 1929.

————. "The New Vision and Its Challenge." March 15, 1919.

————. "Park Popular with Camping Parties." August 23, 1922.

————. "Records Broken by the Radio Station." May 21, 1919.

————. "Richardson Gets Bail and Then Leaves Town." September 10, 1919.

————. "Rights of Citizens Must Be Respected." June 11, 1924.

————. "Rockefeller Arrives at Seal Harbor." July 16, 1919.

————. "Shenandoah Makes World's Record." July 8, 1925.

————. "Star Opens with Sound to Capacity Houses." May 8, 1929.

————. "Star to Install a Sound System." April 3, 1929.

————. "Stotesbury Head of Swimming Club." September 26, 1928.

————. "Submarine Visited Bar Harbor Thursday Night." July 30. 1919.

————. "Tells of Frenchman's Bay Service." November 26, 1924.

————. "37 Reserves Leave this Station." December 14, 1918.

————. "Three Boys Return from Overseas." December 28, 1918.

————. "Tidal Wave Sweeps Bass Harbor Saturday Morning." January 13, 1926.

————. "Town Celebrates Glorious Victory." November 16, 1918.

————. "Two Schooners Wrecked Friday." January 17, 1923.

————. "Two Suspects Arrested in McKinley Bank Robbery." August 27, 1919.

————. "Victory Ball at Club Last Night." August 27, 1919.

————. "Whoopie Revue Is Friday Night." April 24, 1929.

————. "Will Have Automobile Show at Dreamwood." May 8, 1929.

————. "Winter Sports Carnival Tremendous Success." February 28, 1923.

Biddeford Journal. "Denied the Shooting." June 18, 1920.

Clayton, Cathleen Sherman. Unpublished memoir. Jesup Memorial Library Archives, Bar Harbor, ME.

Donnelly, Jim. "Roscoe B. Jackson." *Hemmings Classic Car*, October 2011.

Duffus, R.L. "At Bar Harbor Two Social Ages Meet." *New York Times*, July 28, 1929.

Dwight, Eleanor. *The Letters of Pauline Palmer.* East Hampton, MA: M.T. Train/Scala Books, 2005.

Elden, Alfred. "Maine Fishers Quit Their Island Homes." *New York Times*, March 24, 1929.

Elkins, L. Whitney. *The Story of Maine: Coastal Maine.* Bangor, ME: Hillsborough Co., 1924.

Ely, Burl A. "Cancer Causes Will Be Sought by Dr. Little." International News Service (various newspapers) October 1929.

Engs, Ruth C. *The Progressive Era's Health Reform Movement.* Westport, CT: Praeger Publishers. 2003.

Foster, Patrick. *Hemmings Classic Cars*, November 2005.

Gray, Albert T. "The Log of the *Scout.*" *Motor Boat* 18 (March 25, 1921).

Hale, Richard Walden, Jr. *The Story of Bar Harbor.* New York: Ives Washburn Inc., 1949.

"Italian Villas on the Maine Coast." The Downeast Dilettante. thedowneastdillettante.blogspot.com.

Kenway, Rita Johnson. *Gotts Island Maine.* Bass Harbor, ME: Penobscot Press, 1993.

Lewiston Evening Journal. "Bar Harbor Rum Men Plead Guilty." August 14, 1923.

———. "Dethroned Rum King Prepares for Atlanta." August 15, 1923.

———. "10 Arraigned as Leaders Alleged Maine Rum Ring." June 19, 1923.

Lewiston Evening News. "Hold Maine Man as Rum Ring Chief." June 19, 1923.

Loomis, Alfred F. "The Motorboat Pathfinder." *Country Life*, 1921.

Mount Desert Island Historical Society. Mount Desert Island Cultural History Project. Cemeteries. research.mdihistory.org.

———. Census. research.mdihistory.org.

———. Genealogy. research.mdihistory.org.

New York Sun. "Why Gott's Islanders Moved." December 1928. Reprinted in the *Bar Harbor Times*, December 19, 1928.

New York Times. "Adopted Waif Gets Mrs. Leeds's Riches." February 22, 1923.

———. "Allesandro Fabbri Dies of Pneumonia." February 7, 1922.

———. "Bar Harbor Keeps Junior Yacht Title." August 30, 1929.

———. "Court Returns Liquor." June 7, 1924.

———. "E.T. Stotesbury Badly Hurt in Auto Crash." October 31, 1928.

———. "E.T. Stotesbury, Financier, Is Dead." May 17, 1938.

———. "Governors Ride Dirigible." July 5, 1925.

———. "Identify Peterson's Body." November 27, 1915.

———. "Leeds Adopts a Baby." December 6, 1913.

———. "Mrs. Ellen Kendall Weds." January 13, 1920.

———. "Shenandoah Makes Bar Harbor Flight." July 4, 1925.

———. "Warner M. Leeds Dies." March 26, 1925.

———. "Water Sports at Bar Harbor." August 22, 1926.

Rockefeller, David. *Memoirs.* New York: Random House, 2002.

Stanley, Ralph W. "Rum Running." *Chebacco, The Magazine of the Mount Desert Island Historical Society* 7 (2005).

"Stotesbury Summers." The Downeast Dilettante. thedowneastdilettante. blogspot.com.

Straits Times. "The Kaduskak Case." July 21, 1923.

INDEX

ABOUT THE AUTHOR

Luann Yetter is the author of *Remembering Franklin County* and *Portland's Past*. She teaches writing classes at the University of Maine at Farmington and blogs at luannyetter.wordpress.com.

Visit us at
www.historypress.net
··
This title is also available as an e-book